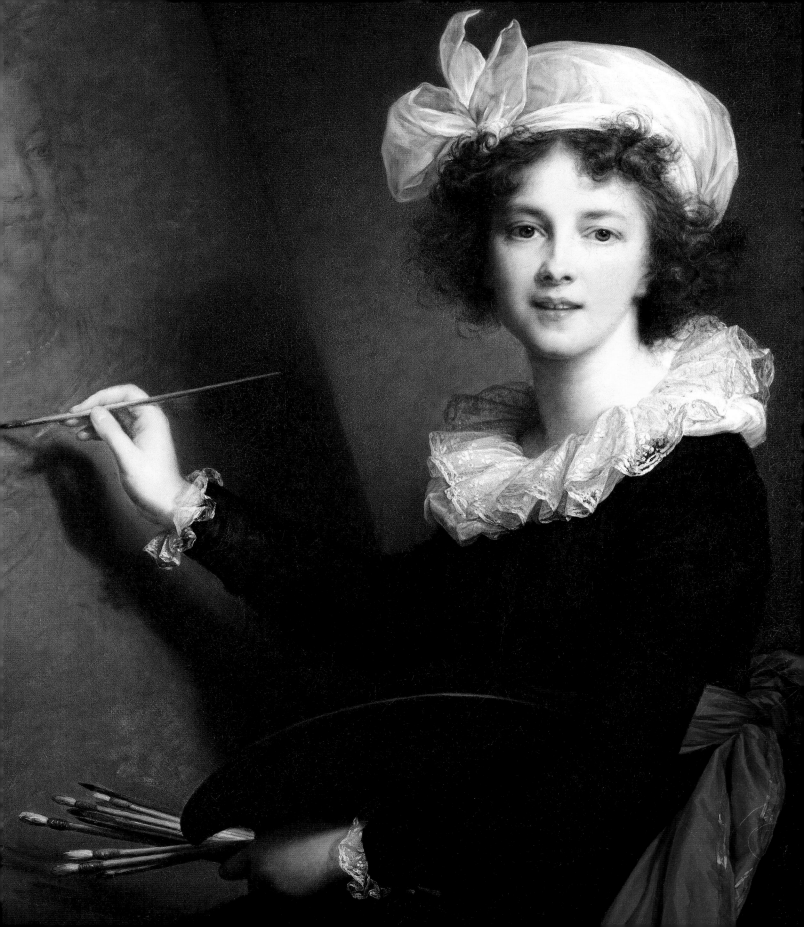

Daring

The Life and Art of

Elisabeth Vigée Le Brun

Jordana Pomeroy

GETTY PUBLICATIONS
LOS ANGELES

For my children, Jacob, Dina,
Anna, and Christian
And my grandsons, Eli and River
With all my love

Note to the Reader

About the art: Unless another artist is identified in the caption, all of the artworks in this book were created by Elisabeth Vigée Le Brun.

About the names: In the 1700s many French people—especially royals and aristocrats—had several given names, often honoring saints or family traditions. These individuals would often choose one preferred first name to go by. For this book, the author has attempted to track down all the preferred first names of the people who are mentioned. The choice to refer to people by their first names both honors their preferences and allows the author to distinguish between those who have the same last name.

Contents

Cast of Characters

CHAPTER ONE

ELISABETH VIGÉE LE BRUN

Daring and talented artist

LOUIS VIGÉE

Elisabeth's father, a portrait painter with a cheerful disposition

JEANNE MAISSIN

Elisabeth's mother, a hard-to-please hairstylist

ETIENNE VIGÉE

Elisabeth's angelic younger brother

JACQUES FRANÇOIS LE SÈVRE

Elisabeth's stingy stepfather

MARIE ANTOINETTE

Queen of France and Elisabeth's future patron

ROSALIE BOCQUET

A gifted artist and Elisabeth's childhood friend

JOSEPH VERNET

Distinguished landscape painter and Elisabeth's mentor

CHAPTER TWO

PIERRE LE BRUN

Well-known art dealer and painter and Elisabeth's husband

JULIE LE BRUN

Elisabeth and Pierre's daughter, nicknamed "La Brunette"

LOUIS XVI

King of France

ROSE BERTIN

Favorite fashion designer of Marie Antoinette

MUHAMMAD DERVISH KHAN

Visiting ambassador from Mysore, India

MAXIMILIEN ROBESPIERRE

Progressive lawyer, advocate for democracy, and key figure in the French Revolution

CHAPTER THREE

MRS. CHAROT

Julie's governess, who travels with Elisabeth and Julie as they flee Paris

LEOPOLDO

Grand Duke of Tuscany

ANGELICA KAUFFMANN

Eminent painter and role model for Elisabeth

AIMÉE DE COIGNY

Duchess of Fleury and close friend of Elisabeth's

MARIA CAROLINA

Queen of Naples and sister of Marie Antoinette

EMMA HART

English dancer and actress and the model for Elisabeth's favorite painting

AUGUSTE DE RIVIÈRE

Brother of Etienne Vigée's wife, Suzanne, and an artist and diplomat

1

A Different Life

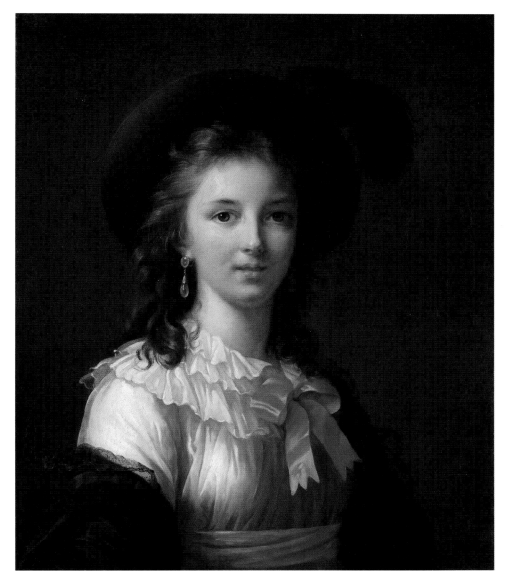

Near the end of her life, Elisabeth Louise Vigée Le Brun published her own story in the form of a memoir—a collection of memories. With her signature charisma, she spun a tale of natural talent, early fame, and a charmed existence filled with parties and musical events attended by royals and aristocrats. She tantalized her readers with gossip about romances and fashion, and she thrilled them with tales of her dramatic escape from revolutionary France and her travels and triumphs in the capitals of Europe and Russia. Marie Antoinette, Catherine the Great, the Prince of Wales, and many other important figures played starring roles in her chronicle. At times, Elisabeth revealed the pain of personal tragedy—but only as much as she wanted her readers to see.

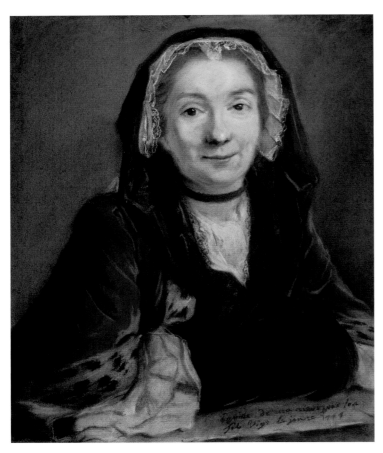

Marguerite Trouvery Vigée by Louis Vigée, 1744

This pastel drawing is a gift Louis made for his mother (future grandmother of Elisabeth), lovingly signed "sketch of my mother by her son Vigée, Jan 20 1744" in the bottom right corner. A tender smile emerges on her face, revealing her delight at being portrayed by her artist son. Louis's family must have been prosperous, judging from his mother's blue velvet jacket trimmed in ermine. Marguerite wears a black neck ribbon, a popular fashion accessory worn by both young girls and older women.

Historians know that memoirs can be unreliable: it's too tempting for authors to embellish their stories or hide unflattering truths, and the details of distant years are hard for anyone to recall. Although Elisabeth's memoir is not entirely inaccurate, it was written to enchant audiences of the 1830s, and it left out a lot. What was it really like to be a famous female artist in a world that disapproved of ambitious women? Where did Elisabeth find the daring to aspire to greatness as a portrait painter? Her talent, persistence, and independence set her apart; she lived an unusual life and left behind an artistic legacy that endures today.

Born into Art

"My life as a young woman did not resemble anyone else's," Elisabeth wrote in her memoir. By the age of fifteen she had a promising career that was typically available only to men. She spent her days painting portraits and improving her artistic abilities and her evenings sharpening her social skills among Parisian high society. How did she start down this path, when most young women her age and rank were expected to marry, have children, and run a household? Like so many professional women artists in history, she was born into an artistic family.

Elisabeth's father, Louis Vigée, was a portraitist who drew with pastels—crayon-like sticks made of powdered pigment. In the mid-1700s, about a century before the invention of photography, informal portraits were in high demand, and pastels suited this popular trend because they were affordable and versatile. "Everyone has a crayon in his hand—as with all that is fashionable, the public has embraced it with a frenzy," wrote one reviewer in 1746. Louis probably made a fine living to support his wife, Jeanne Maissin, and eventually their two children, Elisabeth and her brother, Etienne. Elisabeth's father was known for his cheerfulness and his lively conversation, and he entertained many artists, writers, and intellectuals in the family home. A member of the Academy of Saint-Luc (a sort of union for painters and sculptors), Louis formed many close friendships with artists and writers that would one day benefit both of his children's careers. Jeanne was a hairstylist who

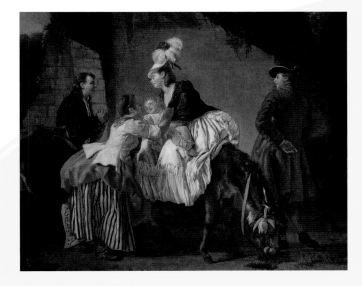

came to Paris from a small town in Belgium. She was attractive, extremely religious, and had a father who supposedly adored her like a goddess. Although it's not known exactly how Elisabeth's parents met, both were part of the world of art and fashion in the same city at the same time. They married in 1750.

Shortly after Elisabeth's birth on April 16, 1755, Louis and Jeanne placed her in the care of a wet nurse in the rural village of Epernon, about fifty miles southwest of Paris, where they would visit her as often as they could over the next five years. While this practice may seem cruel now, it was common at the time across class lines as a service to mothers both wealthy and poor.

Elisabeth's brother, Louis Jean Baptiste Etienne Vigée, came along three years later, on December 2, 1758. Elisabeth thought her baby brother "was as beautiful as

***The Artist's Mother*, about 1774–78**

For this portrait, Elisabeth takes a close-up of her mother, who slightly tilts her head as she gazes out of the picture frame. Her luminous satin jacket, trimmed with swan's down and a light blue velvet bow, is a symphony of textures for Elisabeth's paintbrush. Tucked behind an elegant tiara and another bow, Jeanne's neatly coiffed, pomaded, and powdered hair seems modest in comparison with the big hairstyles popular in the 1770s (see p. 28). As a work from the artist's late teens or early twenties, this portrait demonstrates Elisabeth's tremendous virtuosity as a painter, especially in capturing nuances of light and shadow.

***Farewell to the Wet Nurse* by Etienne Aubry, 1776–77**

Wet Nursing in the 1700s

Wet nurses were women who were paid to breast feed and care for other people's babies and young children. According to the author of *Details of Some Establishments of the City of Paris*, "two or three thousand [infants born annually in Paris] are placed in the suburbs and surrounding territory with nurses of whose integrity the parents have assured themselves, and whose fees are greater on account of their proximity and their convenience." While royalty and nobility had numerous wet nurses at the ready, working women in cities hired rural women who were even poorer than they were. The demand became so widespread in the 1700s that the profession had to be regulated by the Municipal Bureau of Wet Nurses to reduce the number of infant deaths and to standardize wet nurses' monthly salary. Because of economic inequality in France, where the greatest tax burden fell on the poorest people, Paris and Lyon became cities virtually without babies; women had to work out of necessity and had no choice but to send their children to wet nurses in the country.

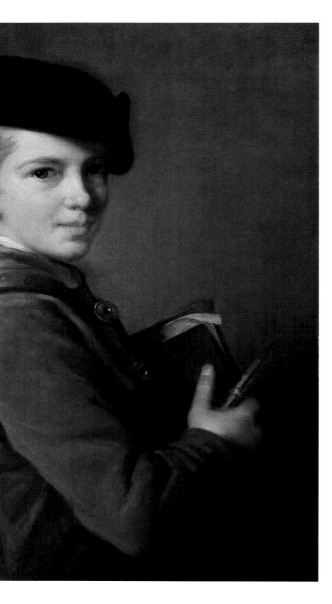

an angel." Her later portrait of Etienne at age fifteen shows him full of confidence as he looks the viewer in the eye. His cherubic, rosy cheeks and full lips attest to his sister's earlier written description of him.

At age six, Elisabeth was sent to a convent boarding school in a suburb of Paris, and her parents would bring her home for visits. Perhaps it was during these stays that she would wander into her father's workspace to watch him create his art. Louis taught Elisabeth to draw and encouraged her to experiment with his pastels. She later wrote, "I remember that when I was seven or eight years old, I sketched by lamplight a bearded man, which I still have. I showed it to my father, who exclaimed joyfully, 'You will be a painter, my child, if ever there is to be one.'"

At school, Elisabeth expressed herself with pencil and chalk, sketching in the margins of her books and those of classmates as well as on the walls of the dormitory. She was constantly in trouble and punished for misbehaving. Much of the school's curriculum centered on religious instruction and the fundamentals of reading, writing, and math. The nuns at the convent also focused on teaching girls obedience and respect. Looking back through a twenty-first-century lens, we might interpret Elisabeth's rebelliousness as a consequence of her restrictive education.

Elisabeth returned home to Paris for good when she was eleven years old. Her father became the leading force in her life, teaching her his profession and introducing her to important artists, writers, and philosophers. He allowed her to sit at the table during dinner parties, and though she was sent to bed before dessert, she recalled laughter and song wafting up to her room. Elisabeth was inspired by the joy her father found in his work. She wrote that he "was so much in love with his art that his passion resulted in bouts of absentmindedness. I remember that one day, all dressed up to have dinner in town, he went out; but with his mind on a painting he had just begun, he came back, intending to retouch it. He took off his wig and put on his night bonnet. . . . Having no neighbors to call attention to his blunder, he went back into town thus attired."

While Louis Vigée showered his daughter with love and attention, Elisabeth was more likely to receive criticism from her mother, especially about her appearance. Jeanne favored her younger child, the angelic Etienne, and Elisabeth took negative comparisons with him to heart. "I had little of his verve, his wit, and especially his good looks, for back then I was ugly. I had an enormous forehead, very deep-set eyes; my nose was the only attractive feature in my pale gaunt face. Moreover, I had grown so rapidly that I couldn't stand straight; I bent forward like a reed. These imperfections were my mother's despair."

A Terrible Loss

Tragedy entered Elisabeth's life for the first time when her father died in May 1767, possibly of an infection following stomach surgery. Elisabeth was only twelve years old, but the memory of her beloved parent and teacher would stay with her always. "My excellent father is still a living presence for me, and I believe I remember all his utterances," she wrote nearly seventy years later. Partly as a way of consoling her heartbroken daughter, Jeanne organized mother-daughter outings to look at important works of art. "My mother found me so downcast by the cruel loss I had suffered that she conceived the idea of cheering me up by looking at paintings," recalled Elisabeth. "We visited the Luxembourg Palace, whose gallery featured the work of Rubens, and where

rooms overflowed with the paintings of the greatest masters. . . . I behaved just like a bee, gathering knowledge and ideas that I might apply to my own art."

Elisabeth's father did not leave an inheritance, which threw the family into a sudden state of financial insecurity. Though Elisabeth was already charging fees for her paintings, these weren't enough to cover household expenses, and her mother had little choice but to search for a new husband to support herself and her children. Only seven months after Louis's death, Jeanne married a wealthy jeweler, Jacques François Le Sèvre. Elisabeth despised him, not least because he was such a cheapskate that he wore her dead father's clothes without even altering them to his size. "We had never suspected him of stinginess, but he soon revealed himself to be a miser denying us even basic necessities, despite the fact that I naively gave him everything I earned." Though a friend advised her to keep her income for herself, Elisabeth was worried that her mother might suffer unnamed consequences if she did.

Elisabeth's stepfather moved his new family into an apartment above his silver- and goldsmith's shop on the elegant rue Saint Honoré, in the heart of Paris's fanciest shopping district. Outside the luxury stores and art dealers' shops, the sidewalks bustled with buyers and sellers from all over France and abroad. These merchants catered to the working class who purchased

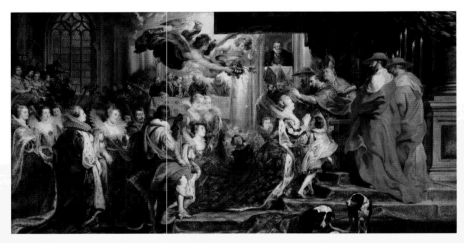

Coronation in Saint-Denis by
Peter Paul Rubens, 1622–25

Rubens the Rock Star

Peter Paul Rubens came from Flanders, the southern part of the Netherlands now called Belgium. A prolific painter and learned man, he was larger than life as an artist, a diplomat, and an antiquarian. His painting style of loose brushwork to convey movement and his use of vibrant color made him a standout in the history of art. Given her love of the theatrical, which she infused into her portraits through costuming, Elisabeth soaked in the artist's twenty-four paintings on display at Luxembourg Palace, which glorified the life of the French queen

Marie de' Medici. The Flemish artist knew how to play to his patron's ego and her importance as a queen. He raised her status to the realm of godliness and celebrated her bravery and heroism as the default ruler of France after her husband's assassination in 1610.

In this coronation scene, Marie de'Medici is led to the altar by men of the church and of the court. Hovering above, Abundantia (goddess of plenty, or riches) and the winged Victoria (goddess of victory) pour golden coins of Jupiter around Marie.

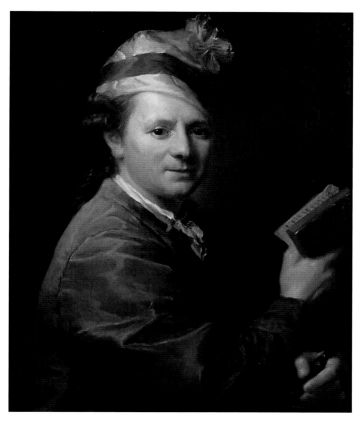

Jacques François Le Sèvre,
about 1774

This animated portrait belies
Elisabeth's venomous feelings
toward her stepfather. Here he
holds a book and a magnifying
glass, suggesting a certain
level of education. He wears
a stylish dressing gown and
matching nightcap, casual
wear of the time.

Cafe du Bosquet, rue Saint-Honoré, Paris, **engraving
by an unknown artist, about 1795–99**

Luxury and Shopping

The rue Saint-Honoré of the 1700s was like
today's Rodeo Drive or Fifth Avenue—a shop-
ping destination for the rich and famous.
Paris was full of people associated with the
royal court as well as the French aristocracy.
Many artists and artisans and a large labor
force filled an increasing demand for luxury
items, which included clocks, books, jewelry,
and decorative objects made from gold,
silver, and porcelain. The middle and working
classes also developed a taste for fancy
goods, nurturing the market for less expen-
sive reproductions.

New trade routes with India and China
brought in tea, coffee, chocolate, sugar,
and tobacco. There were also silks, linens,
and cottons dyed with indigo from the French
colony of Saint-Domingue (present-day
Haiti). Enslaved people on the distant Carib-
bean island handpicked and processed the
indigo plant's leaves to extract the deep-blue
dye. Elisabeth painted both men and women
wearing a variety of garments colored with
indigo, including Marie Antoinette's gown on
page 35. Indigo is one example of how
demand for luxury in Europe's wealthiest
countries perpetuated cruel systems of
slavery in other parts of the world.

off-brand, less costly imitations of everything from
clothing to housewares.

In contrast to the excitement of living in the
heart of Paris, weekends at her stepfather's cramped
cottage in the country village of Chaillot were unbear-
able. Elisabeth, greatly bored, complained bitterly.
"Picture a very small parish priest's garden: no trees,
no shelter from the sun.... It was divided into four by
small sticks and the three other sections were rented

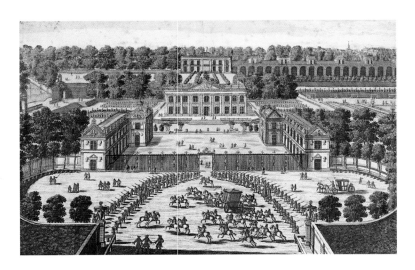

View of the Château de Marly by Pierre Aveline, 1720

The royal château of Marly, the construction of which began in 1679 during the reign of Louis XIV, was intended as a country vacation spot for the king and members of his court. The ambience was relaxed. Courtiers could wear their hats in the presence of the royals, enjoy musical performances, hunt in the surrounding woods, and wander in the tremendous gardens around the château.

Self-Portrait by Rosalie Bocquet Filleul, 1775

In this self-portrait, Rosalie depicts herself as a successful professional artist. Attired in an indigo-colored velvet dress, with a wide collar edged with gold embroidery and a pink silk bow, Elisabeth's close friend holds a paint palette on her left arm and a delicate paint brush in her right hand, her pinky elegantly raised. No messiness can be detected in this portrait, which is as much about Rosalie's social standing as her artistic talents.

to shop assistants, who entertained themselves every Sunday by shooting at birds. The constant noise reduced me to despair, besides which I was terrified of being killed by these oafs, who couldn't aim straight." Jeanne's friend Madame Suzanne came from time to time to rescue Elisabeth from these tedious weekends and take her on trips as a distraction. It was on one of these outings that Elisabeth first laid eyes on Queen Marie Antoinette, her future patron. The queen, accompanied by ladies of her court, was strolling the park of Marly-le-Roi, a country estate east of Paris. Elisabeth recalled bowers of jasmine and honeysuckle that covered six pavilions surrounding a chateau whose magnificent fountains spewed water as high as mountains, creating a large canal where swans floated.

The trauma caused by the death of her father and the quick remarriage of her mother dampened Elisabeth's enthusiasm for making art. Only very slowly did two of her father's associates and her best friend, Rosalie Bocquet, coax her back to her artistic practice, which helped her overcome her grief and get her career back on track.

One of Louis Vigée's dearest friends had been the painter Gabriel François Doyen. He encouraged Elisabeth to take lessons from another painter, Gabriel Briard. These were not major artists but nevertheless members of the prestigious Royal Academy of Painting and Sculpture. Their professional support was evidence of Elisabeth's potential, and her willingness to challenge herself with intense study showed her strong motivation to become part of their world. Perhaps she dreamed of continuing her father's legacy, in addition

to wanting to help her family financially. In any case, it was around this time that Elisabeth reached a crossroads with her art. Still in her early teens, she began to build a serious reputation and to charge her customers accordingly.

Elisabeth and her friend Rosalie had a lot in common. Like Elisabeth, Rosalie was an artist, came from an artistic family, and studied with Gabriel Briard. Her father, Blaise Bocquet, painted fans and owned a curio shop, and her mother, Marie Rosalie Hallé, ran a small school that taught drawing. The two girls ate lunch together at the Louvre—a former palace that now housed the Royal Academy—where their teacher had a residence and gave lessons. Elisabeth went to Rosalie's house in the evenings so they could draw together. In Rosalie, Elisabeth found a rare friend who shared her interest in art and provided company and encouragement.

Moving Ahead

Within two years of the loss of her father, Elisabeth was coming into her own as an artist, and her self-image had vastly improved. "Mademoiselle Bocquet was fifteen at the time, and I fourteen. Each of us was prettier than the other (I had meanwhile undergone a transformation and become good-looking). Her [Rosalie's] aptitude for painting was remarkable, and my progress was so rapid that I had begun to make a name for myself, which earned me the pleasure of meeting Joseph Vernet."

An accomplished painter of marine scenes and landscapes, Joseph Vernet would become Elisabeth's friend and mentor. He advised her to copy paintings by eminent artists of the past and to focus on Italian painters, but also to educate her eye by exploring Flemish art as well. His message to Elisabeth was clear: Don't waste your time in school, because nature will serve as your greatest teacher. As a painter of the outdoors, Joseph had given much thought to the ideas evident in the landscape paintings of Claude Lorrain, Gaspard Dughet, and Salvator Rosa, each a renegade in his approach to capturing nature with both scientific clarity and emotional depth. Already in midcareer, Joseph had an international clientele, which likely helped Elisabeth establish her reputation among the titled gentry. When she later painted a portrait of her mentor, it was considered her most accomplished to date.

Elisabeth understood that success as an artist came not from talent alone but also from connections to other artists, potential patrons, and important organizations. She learned to parlay social events into networking opportunities. Dinners in general were often less about the food than the company. "There was much amusement and laughter. It was customary in those days to sing at dessert: Madame de Bonneuil, who had a charming voice, sang duos of Grétry with her husband. Then came the turn of all the young ladies, for whom

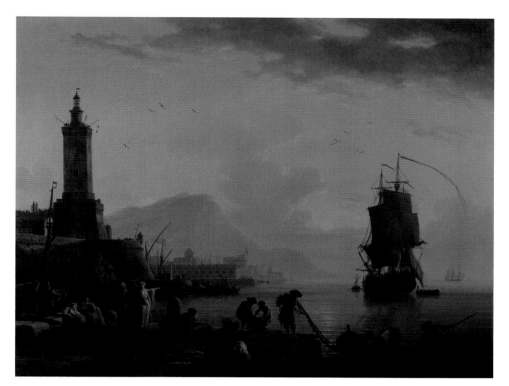

A Calm at a Mediterranean Port by Joseph Vernet, 1770

Soft sunset tones of yellow and orange shimmer across the water in this idealized scene of a day by the sea. Fishermen clean the day's catch while a variety of people chat nearby.

this fashion was sheer torture—they would turn pale and tremble and often sing out of tune. Despite these trifling dissonances dinner would end on an upbeat note, and we all regretted having to part." In addition to her artistic skill, Elisabeth had a quick wit, good looks, and a flair for fashion, which attracted new clients—sometimes along with unwanted attention. She recalled, of painting portraits of certain men: "As soon as I perceived that they were casting fond glances at me, I painted them with their heads at an angle, which prevented them from looking at the painter. If they shifted their head in my direction, I would tell them to keep looking straight ahead, that I was painting their eyes. That irritated them, as you can imagine, and my mother, who never left my side, and in whom I confided, chuckled under her breath."

In her late teens, Elisabeth recognized that she was choosing a path different from that of the other young ladies she encountered at parties. She began to decline social invitations during the daytime to focus on her painting and assert herself in a male-dominated world. Both she and Rosalie applied to the Academy of Saint-Luc, the union of professional painters to which her father had belonged. For her guild submissions, Elisabeth exhibited her interpretations of painting, poetry, and music in the form of allegories. The term *allegory* comes from Latin and means "veiled language," and in art it refers to figures that personify an ideal. Of the three paintings she submitted, only the whereabouts of *Allegory of Poetry* are known, but even on its

Joseph Vernet, 1778

In this portrait, Elisabeth captures her mentor in a contemplative moment; he appears to pause from painting to consider his next approach to the canvas. Light falls on the oil paints on his palette and brush, which glisten and act as a colorful foreground to Joseph's elegant dark waistcoat and white shirt with decorative lace cuffs and cravat.

The Forbidden Figure

Mastery of human anatomy had become a way for male painters to dominate the art world at this time. The most profitable subject matter—history painting, which included classical mythology and biblical scenes—required knowledge of the human body. However, painting live nude models was off-limits to women artists. "Protecting" their morality served as an excuse to limit women to the less prestigious areas of portrait and landscape painting.

For a woman, studying the nude would have been a private enterprise, confined to studying herself or perhaps a willing partner. Some women painters like Elisabeth dared to include scenes from classical mythology and religion in their work despite these restrictions. Her risk paid off when her *Allegory of Poetry* gained her admittance to the Academy of Saint-Luc.

Allegory of Poetry, **1774**

In the 1980s an art historian identified this painting as one Elisabeth described in her memoir. In an art sale in 1949, it had been attributed to the artist François André Vincent. There are many such examples where works by women artists were incorrectly attributed to men whose names were better known and could fetch higher prices. All three of Elisabeth's allegories were presumed lost until this one was identified. The art historian likely recognized it immediately from Elisabeth's style of painting. Because only this one of a series of three paintings has been found, it is possible that the other two still exist somewhere, unknown to us but in clear view, perhaps in a private home or exhibited under another artist's name.

own, it demonstrates Elisabeth's advanced prowess in depicting the human form. *Allegory of Poetry* presents a physical idea of what poetry might look like in Elisabeth's mind: a beautiful woman, half draped, reclining on her left arm and gazing skyward while about to compose a poem on an empty page. Not only about poetry, the work is also designed to showcase the artist's expertise in technique, composition, imagination, representation of the human body, and knowledge of history.

One critic commented that "this young virtuosa has . . . proven her talent for history subjects. . . . The color is agreeable, the brush deft, the stroke sure." Elisabeth would find success with this presentation work, which gained her admittance to the Academy of Saint-Luc and distinguished her as a woman artist competitive in a male-dominated arena.

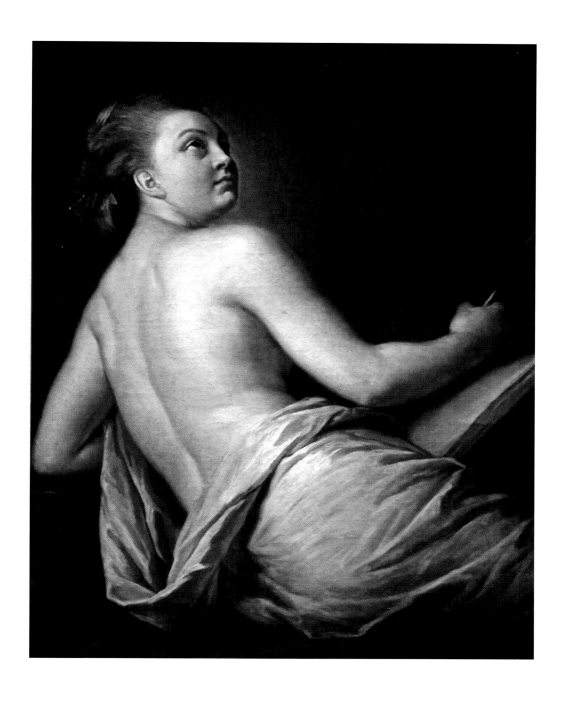

2

Self-Invention

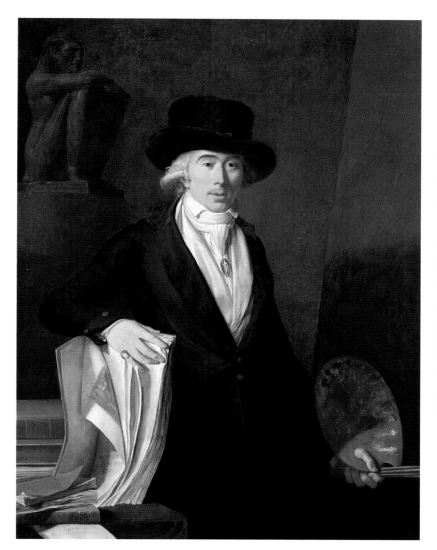

Self-Portrait by Pierre Le Brun, 1795

Starting in the 1700s, men began wearing a three-piece suit known throughout Europe as an *habit à la française*. Pierre selected his attire with great care. According to Elisabeth, "during the summer, when at home, he wore frock coats of white bazin fabric, . . . breeches of Nanking silk imported from India, white silk stockings, and shoes with golden buckles. During the other seasons, he dressed with the greatest of luxury. He powdered his hair and carried a little cane, which he handled gracefully and with great agility, to the amazement and delight of his niece when she was still a child." Not only does Pierre portray his passion for fashion, he also proudly displays in this self-portrait the second of three volumes of his monumental work on Flemish, Dutch, and German painters, as well as his painting palette and brushes.

Although she was pleased to be admitted to the Academy of Saint-Luc, Elisabeth's bigger, wilder dream was acceptance into the more prestigious Royal Academy of Painting and Sculpture. Over its 145-year history, the Royal Academy admitted 450 men and only fifteen women. This absurd ratio was just one of the many hurdles facing French women artists in the 1700s; they also dealt with sexist attitudes, exclusion from most art schools and apprenticeships, and a rigid professional system. Against these odds, membership in the elite Royal Academy would be a huge accomplishment. It would also give Elisabeth access to more clients and more money, since the academy was where royals and other powerful people sought artists when they wanted a painting. But in addition to simply being female, Elisabeth would encounter another barrier (or trumped-up excuse) to her admission. It had to do with a handsome young art dealer named Jean Baptiste Pierre Le Brun.

Genius and the Female Body

Many people in Elisabeth's day thought that biology made women incapable of becoming great artists. Doctors believed that women's "sensitive" internal organs and "rapid movement of nerves and muscle fibers" made them temperamental, vulnerable to the effects of passion, and lacking in the discipline and talent necessary to achieve success. For example, in 1775 the physician Chauvot de Beauchêne claimed that women's sensitivity compensated for "that which is lacking in the profundity of their ideas, in the force of their reason, and in creative genius, which by right belong to man."

There were a few voices raised on behalf of women's equality. One human rights activist of the period, Olympe De Gouges, wrote, "I offer a foolproof way to elevate the soul of women; it is to join them to all the activities of man." She argued that women should have the same rights and opportunities as men, including the right to own property, to receive equal education, to vote, and to hold public office.

Women artists, writers, and musicians were always a real presence in Western European history, but they were mostly ignored by the writers of that history—predominantly, white men who underestimated the minds that come in female bodies.

Charming and passionate, twenty-six-year-old Pierre lived in the Hôtel de Lubert, a large mansion on the rue de Cléry in Paris. In 1774, when Elisabeth was nineteen, her stepfather moved the family into a rented wing of the same building. Pierre was already a well-known art collector, painter, and dealer in important European paintings. He invited his new neighbor over to see his collection, and he delighted in sharing his extensive knowledge with her. For Elisabeth, it must have been heaven to have practically a private museum within the same walls as her own home. Pierre gave her unlimited access to his paintings, and he even loaned her some of his most valuable works to copy. (Copying paintings was a traditional part of artistic training, important for learning not only the art of drawing but also the art of inventing scenes and compositions.) Elisabeth called her visits with Pierre the best lessons she ever could have had.

After six months, Pierre asked Elisabeth to marry him. She was surprised—and less than enthusiastic. "I was far from wishing to become his wife, though he was very well built and had a pleasant face," she confided in her memoir, in which she also called him sweet, lighthearted, and kind. "I was only twenty years old. I didn't worry about my future since I was earning lots of money, so I had no desire to marry. But my mother, who believed Mr. Le Brun to be very rich, kept urging me not to refuse such an advantageous match. I decided to get married impelled by the desire to escape the torment of living with my stepfather, whose ill humor grew worse every day." The wedding was held in 1776, and on the way to the church, Elisabeth remembered, she was still asking herself, "Shall I say yes, or shall I say no?"

The Art of the Art Business

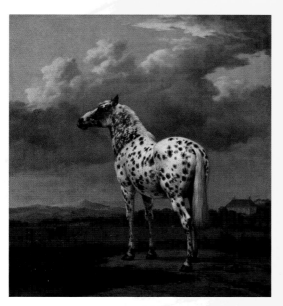

The "Piebald" Horse by
Paulus Potter, ca. 1650–54

Pierre Le Brun would become one of the most respected art dealers and connoisseurs (experts) of his day. He encouraged buyers to think of art as an investment, based on its stable value over time. He also developed an international art trade and increased the French market for Dutch paintings by writing about and selling works by artists such as Johannes Vermeer, Pieter Saenredam, and the animal painter Paulus Potter, who were not yet well known among French collectors. Pierre wrote and published extensively on art and artists—even releasing a a major survey of the painters of Northern Europe. As an art specialist, he emphasized careful observation and comparison of works to spot stylistic similarities and differences.

She would later write that by saying yes she simply traded her old problems for new ones. It seems Pierre loved to gamble, live well, and buy nice things, and he was often short of money to support his business. Soon, not only was he taking control of Elisabeth's income—which, as her husband, he was legally entitled to do—he also was insisting that she give art lessons to young ladies to earn extra cash on the side. This mostly annoyed her, as teaching took time away from her portraits, which she often had to work on late into the night. She did share one lighthearted story about a day she entered her attic studio to find that her pupils had tied a rope to one of the rafters and were enjoying swinging back and forth. After using her most serious grown-up voice to give them a scolding, she couldn't resist her own mischevious nature and joined in the fun.

Styling the Queen

As her popularity grew, Elisabeth continued to produce a vast number of portraits. These began to include likenesses of counts and countesses, duchesses, and officials from the royal court. In 1778 she was called to the palace of Versailles to paint twenty-three-year-old Queen Marie Antoinette.

For one formal portrait, Marie Antoinette placed herself and her dressmaker Rose Bertin at Elisabeth's disposal. As the queen's favorite, Rose was the leading fashion designer of the French aristocracy. It is interesting to think of Elisabeth and Rose as Marie Antoinette's publicity team, helping her to

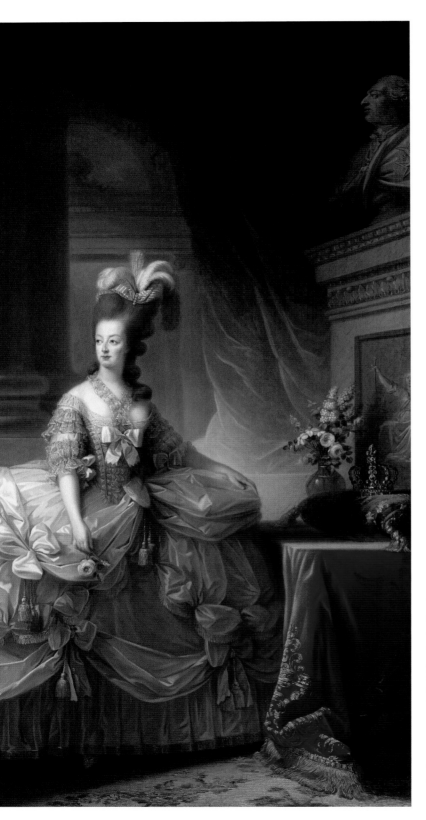

**Marie Antoinette in Court
Dress, 1778**

This painting's sole purpose
was to depict the dominion
of the new queen in her
palatial quarters, under the
reign of her husband, Louis
XVI. On the high mantel,
a bust of the king appears
to be looking over his wife,
who may have been pregnant
at the time with their first
child. The formal dress of
white satin was worn with
panniers—iron hoops that
extended the width of a skirt
up to six or eight feet.

The Young Queen

Marie Antoinette had a role to play in international politics before she even had a name. The fifteenth child of Holy Roman Emperor Francis I and Archduchess Maria Theresa of Austria, from the day of her birth on November 2, 1755, she was expected to seal the alliance between Austria and France by marrying the heir to the French throne. Royal families arranged marriages to strengthen their kingdoms, and each of Maria Theresa's children held the potential to further the reach and power of the Habsburg dynasty. The official marriage proposal was brought to Vienna in 1769, when Marie Antoinette was thirteen years old. The following year, she married the French dauphin (crown prince) Louis Auguste, who would become King Louis XVI, with her brother acting as a stand-in for the groom. At age fourteen, Marie Antoinette entered Paris as a married woman, not yet having met her husband but already recognized by the French as a paragon of beauty and virtue.

The future king and queen of France celebrated their marriage lavishly in the palace of Versailles, the epicenter of European power and taste. The couple, as young and sheltered as they had been, were quite shy with each other. They had separate bedrooms and led separate lives, but they were cordial to each other. Louis XVI's later gift to his wife of the Petit Trianon, a small but elegant residence located in the beautiful Versailles gardens, became Marie Antoinette's hideaway, a place where she could escape the rigid lifestyle of the palace. She could let her hair down at the Petit Trianon, be herself, play games, put on plays, and entertain her closest, trusted friends. Still, she knew she couldn't afford to neglect her public image, and she understood the importance of official portraits as statements of her identity.

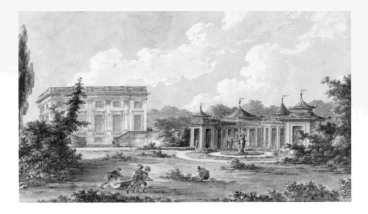

View of the Petit Trianon by
Claude-Louis Châtelet, 1786

project her authority through her choice of clothing, hairstyle, pose, and surroundings. In this work the queen dominates a palatial room with her wide court gown and elaborate, feather-topped hairstyle.

Elisabeth would end up painting more than thirty portraits of Marie Antoinette and her family, becoming quasi-official artist to the queen. She would write, "The shyness I felt on my first encounter with the queen had entirely given way under the kindness she always showed me. As soon as Her Majesty heard that I had a pretty voice, she wouldn't let a sitting go by without us singing duets . . . because she adored music even though she sang off-key."

When Elisabeth was twenty-five, she gave birth to a daughter, Jeanne Julie Louise Le Brun, known as Julie and also by the nickname

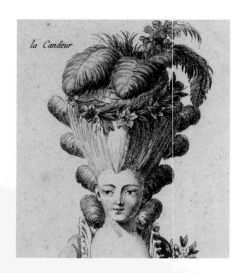

la Candeur

Example from *French Designs for Coiffures* from 1776, engraving after Gabriel Jacques de Saint-Aubin

"La Brunette," which alluded to both her last name and her brown hair. A year or two after that, the Le Bruns took an extended trip together to Flanders, Germany, and Holland, where Pierre purchased paintings to sell to wealthy collectors back in Paris. Elisabeth fondly recalled this trip, on which they viewed a sale of paintings that belonged to a prince. She mingled with aristocrats and toured private collections filled with important works, especially noting portraits by such Flemish painters as Anthony van Dyck. A painting by Peter Paul Rubens of a woman in a feathered hat inspired Elisabeth to create a similar self-portrait. It became one of her most popular paintings and was reproduced as an engraving. In Holland, the artist commented that the cities of Saardam and Maastricht were "so clean and so well kept that one envies the lot of the inhabitants." It would not have escaped Elisabeth's attention that here, unlike in crowded, dirty Paris, she could walk in the streets without fear of ruining her shoes.

About the Hair

The ideal woman of the 1770s had black, brown, or blond hair; red hair was unpopular and typically dyed a different color. Women generally did not wear full wigs but powdered their hair with corn flour, wheat flour, or finely milled starch. The powder was usually white (which would make dark hair appear gray), but it could also be brown, gray, orange, pink, red, blue, or violet. The mid-1770s saw the literal rise of the "pouf," a wire scaffolding over which a woman's hair was lifted to impressive heights, enhanced by flowers, feathers, and jewels. In the 1780s, a more natural hairstyle became fashionable; it was cut shorter in front to create a frizzy or curly halo, with longer hair formed into ringlets or braids hanging down the back. This style can be seen in Elisabeth's self-portrait of 1782 (p. 29) and the queen's portraits of 1783 (pp. 34, 35).

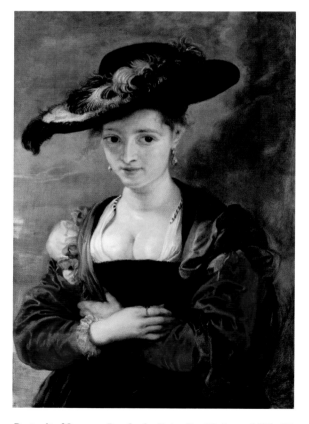

Portrait of Susanna Lunden by Peter Paul Rubens, 1622–25

Elisabeth was so inspired by *Portrait of Susanna Lunden* that she painted her own self-portrait flaunting an exquisite straw hat with a lush feather (p. 29), to which she added a garland of wildflowers around the brim.

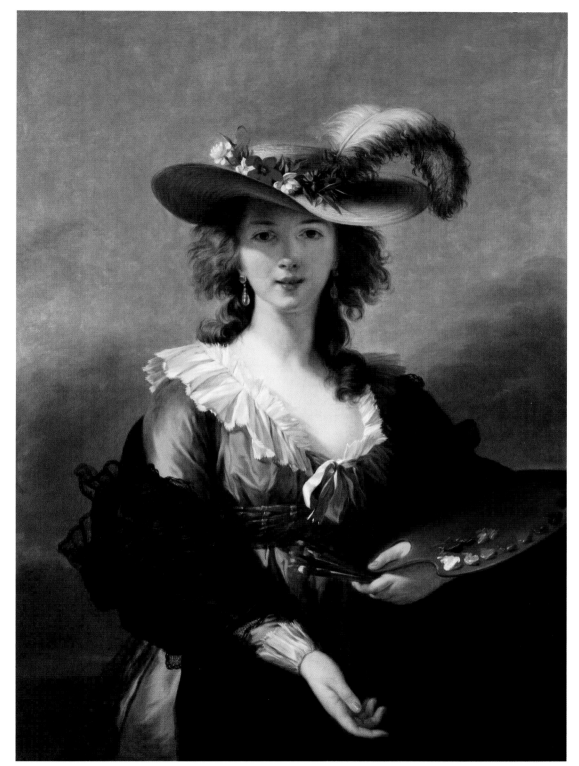

Self-Portrait in a Straw Hat, 1782

Here the artist portrays herself as if caught in midconversation with the viewer, her wide eyes and open lips commanding our attention. Against a blue sky, with her wavy hair barely wafting in the breeze, Elisabeth appears poised and still; her painting palette suggests a woman in control of both nature and her craft. With this self-portrait, Elisabeth not only paid homage to Peter Paul Rubens but also visually aligned herself with history's great artists.

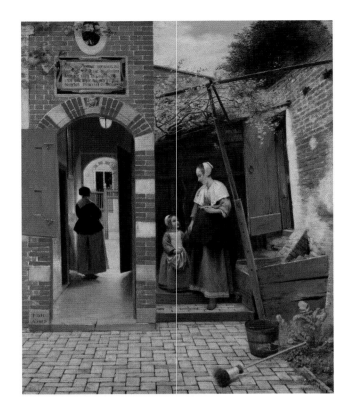

The Courtyard of a House in Delft by Pieter de Hooch, 1658

Pieter de Hooch excelled in depicting the everyday lives of women and children in the Netherlands. In this painting, we see a sparklingly clean marble entryway and cobblestone street. A broom and washbucket in the foreground highlight the hard work of Dutch housewives.

Back home again, Elisabeth dove into her work at a furious pace. Her career was taking off, and the highest realms of success seemed within reach. Perhaps now she had a chance to gain admittance to the Royal Academy of Painting and Sculpture. But there were still those members who disapproved of women painters, like Count d'Angiviller, France's powerful minister of fine arts, who claimed that women "can never be useful to the progress of the arts." And now there was another problem: Elisabeth had a prominent husband who traded in paintings, a commercial activity that was frowned upon by the elite artists' academy. Because of her marriage to Pierre, her dream of membership seemed as far away as it had back when she and Rosalie were students copying drawings at the Louvre.

By now, Rosalie had married a much older man, Louis Besne Filleul, and she had a son. She no longer actively pursued an art career, though she undertook a few pastel works and paintings, including a portrait of her neighbor Benjamin Franklin, the American ambassador to France.

In 1783 Elisabeth's powerful patron Marie Antoinette finally intervened on her behalf. Though the Royal Academy continued to exclude anyone involved in the buying and selling of art, the queen's support led the academy to the decision that, because Elisabeth herself was not involved in her husband's business, it was okay to let her in. She was admitted the same year as another female painter, Adélaïde Labille-Guiard, along with three men, including Jacques Louis David.

Life at the Top

At last, Elisabeth was a member of France's highest artistic circle, and she would be allowed to display her paintings in the Paris Salon, the Royal Academy's important annual showcase of new art. The Salon attracted huge crowds, and the artists and their paintings became the talk of the town for months. For that year's entry, Elisabeth painted a lovely portrait of Marie Antoinette wearing a simple white dress (p. 34). Tired of carrying around the weight of heavy silk and satin court gowns, Marie Antoinette and her circle had adopted a new fashion called the chemise: a light, white dress made of muslin and tied with a sash.

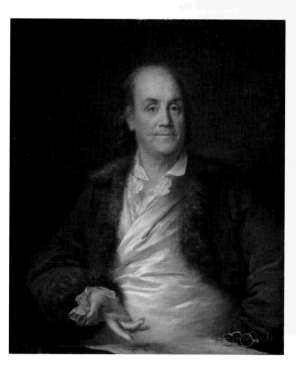

An American in Paris

In his role as a delegate to the Continental Congress, Benjamin Franklin traveled to France to secure French assistance for the American colonies, who were fighting for their independence from British rule. Franklin, with the help of the Marquis de Lafayette and other influential figures in the French government, convinced King Louis XVI to aid the Americans. This effectively weakened Great Britain, a longtime adversary of France. Newspapers, pamphlets, letters, and other reports carried news of the American Revolution to Europe, British North America (Canada), the Caribbean colonies, India, China, other parts of Asia, and to African coastal cities engaged in the transatlantic trading of enslaved people. Now the ideas of liberty and democracy were spreading around the world, and they would become a catalyst for the French Revolution in 1789.

Benjamin Franklin by Rosalie Bocquet Filleul, 1778/79

The style not only represented more modern and comfortable attire for women but also projected a more down-to-earth image for the queen. When the portrait went on display at the Paris Salon, it sparked a firestorm of disapproval: many people thought the queen was basically posed in her underwear. Her casual attire gave ammunition to those who were already spreading rumors about her inappropriate behavior and lack of modesty. The painting was so scandalous that Elisabeth quickly made a substitute portrait of the queen to exhibit in its place (p. 35). It was a reminder to Marie Antoinette that, while she might pursue her unconventional life of comfort, music, and beauty at the Petit Trianon, she could never let down her guard in public.

Elisabeth continued to work nonstop, holding as many as three portrait sittings a day. Soon she wore herself out; she developed stomach troubles and grew dangerously thin. A doctor recommended naps after lunch, which she credited with saving her life. Eventually she became pregnant again. In her memoir, she mentioned missing a portrait sitting with Marie Antoinette late in her pregnancy because she felt very ill. When she went to Versailles the following day to apologize and reschedule the appointment, the queen showed not

displeasure but concern. According to Elisabeth, "The queen turned toward me and said sweetly, 'I waited for you all morning. What happened to you?'

"'Alas Madame,' I answered, 'I was so ill that I couldn't obey your Majesty's orders. I've come today to receive them, and I will leave immediately.'

"'No, no, don't leave,' the queen responded. 'I don't want you to have made this trip in vain.'

"She cancelled orders for her coach and gave me a sitting. I remember that in in my haste to acknowledge this kindness, I grabbed my box of colors so briskly that I spilled it. My brushes, my paintbrushes, fell on the floor. I bent over to set things right. 'Don't bother, don't bother,' said the queen, 'You're too pregnant to be bending over.' And no matter what I said, she bent over herself."

The story shows a sweet moment between two young women of the same age, both mothers. Because of their different stations in life, the relationship would not have been called a friendship, but it was certainly based on mutual understanding and respect.

Elisabeth's second baby girl arrived in 1784 and, tragically, died soon after she was born. Julie would be Elisabeth's only living child, the focus of all her mother's affection, and the subject of at least a dozen of her paintings (pp. 37, 46, 58, 83). Tender portraits of mothers and children would become one of Elisabeth's specialties over the following years.

Celebrity Nightlife

Whether to ease her heartbreak, support her family, advance her career, or likely all of the above, Elisabeth continued to pour her energy into her art during the day and to keep up a marathon social schedule in the evenings. One society watcher said, "She is a young and pretty woman, full of wit and poise, quite amiable, seeing the best society of Paris and Versailles, giving delightful supper parties for artists, authors, people of quality; and her home is the sanctuary where the Polignacs, the Vaudreuils, the Polastrons, the most highly placed and refined courtiers, come to seek refuge from the tedium of court life." In addition to entertaining at home, Elisabeth was frequently invited to dinners across Paris, and there were sometimes balls where she danced the quadrille, though she wasn't a huge fan of dancing. She was passionate about theater and music, and she loved parties where she and the other guests would sing and act out comedies and operas.

Elisabeth took a cue from the performing arts by costuming her sitters in flamboyant hats, gauzy veils, lace cravats, and embroidered coats. She spared no detail in her representation of clothing, which was as much about status as fashion. A large part of Elisabeth's success as a portraitist was the intelligence to understand that each of her subjects wanted to convey a specific identity to

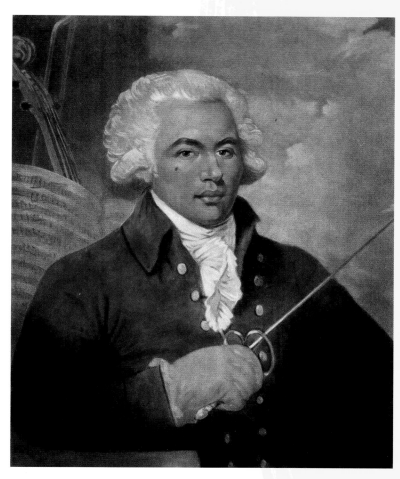

Knight of Saint-Georges, engraving by
W. Ward after Mather Brown, 1788

Artists of Color

Elisabeth did not encounter many individuals of color. The Black population of France in the 1700s was small, though hundreds of thousands of enslaved Black people worked under harsh conditions in French colonies in the Caribbean. There were some notable exceptions to the racial homogeneity of Parisian society, including Joseph Bologne, Knight of Saint-Georges. Born in Guadeloupe to a white planter and his wife's enslaved Senegalese maid, Joseph came to France at age seven for his education. He became a champion fencer as well as a brilliant violinist and composer. Louix XV named him a chevalier, or knight, after his father's noble rank. The American diplomat John Adams described him as "the most accomplished man in Europe in riding, shooting, fencing, dancing, and music."

In her memoir, Elisabeth mentioned that "the famous Saint-Georges often played violin to the crowds" outside the Paris Opera in summertime. Marie Antoinette, who played the pianoforte, invited Joseph to Versailles to play duets with her. It is likely that Elisabeth met Joseph through her connection to the queen, but she never painted his portrait.

Guillaume Lethière was also born in Guadeloupe to a white plantation owner and an enslaved woman. He came to France at age fourteen, and he studied drawing and painting in Rouen. He won prizes for his drawing at the Royal Academy of Painting and Sculpture in Paris. At age twenty-six, he won the competitive Prix de Rome, which gave him the opportunity to study art in Italy. In her memoir, Elisabeth mentions Guillaume by name as a talented history painter who accompanied her on a treacherous climb up Mt. Vesuvius and sketched her riding a donkey. Guillaume knew other men and women from the French colonies in the Caribbean, many of whom were born enslaved and then freed. Among these were Benjamin Rolland from Guadeloupe, who learned from the famous artist Jacques-Louis David and built a career as a painter. Théodore Chassériau, born in the Spanish colony of Santo Domingo (now the Dominican Republic), moved to Paris at age one and eventually became a portrait painter.

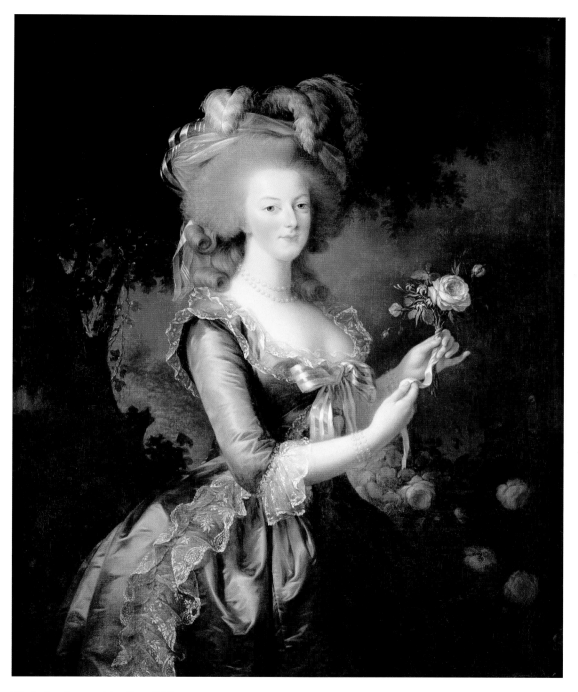

Marie Antoinette with a Rose, 1783

In this portrait, Marie Antoinette wears a satin,
lace-trimmed *robe à l'anglaise* (English-style gown).
A bow at the center emphasizes her tight bodice.
The dress, simple and opulent at the same time,
offers a version of the queen as the model of elegance
and propriety.

Fabric as Light as a Cloud

The muslin fabric of the 1700s can no longer be made today. Then, artisans in Bengal, India, used an indigenous type of cotton plant called *Phuti karpas*, which has since become a victim to biodiversity loss. Expertly woven muslin fabric—so fine and light it almost seemed to float around the body—became a highly coveted export from Bengal to France in the 1700s. In her paintings *Marie Antoinette in a Chemise Dress* (p. 34) and *Portrait of Muhammad Dervish Khan* (p. 47), Elisabeth expressed utter joy in depicting delicate layers of the light white material.

Julie Le Brun with Mirror, 1787

Elisabeth painted her daughter many times during childhood; Julie is seven years old in this double portrait. In painting Julie this way, Elisabeth adoringly shows off her daughter from multiple perspectives, the mirror allowing for both Julie's full face and her profile to be seen. The red lacquered mirror depicts Asian figures, reflecting the Western European fashion for chinoiserie, a style of decoration inspired by Chinese art and culture.

the world. In her paintings, clues abound to indicate the sitter's social rank, profession, hobbies, and talents. Elisabeth painted the Viscountess of Vaudreuil and the Baroness of Crussol Florensac with each woman engaged in an intellectual pursuit (pp. 39, 40). The viscountess is shown holding a book, and the baroness holds the bound score of *Echo et Narcisse*, an opera by Christoph Willibald Gluck. Literate, musical, and well placed in society, the viscountess, baroness, and their female friends would have gathered with prominent men in salons to discuss topics of interest emerging from the Enlightenment. Different from the official Paris Salon, which was an art exhibition, private salons were intellectual events hosted by women.

The importance of the salon as a statement of one's intellectual powers—as well as a place to meet potential new clients—was clear to Elisabeth, who decided to host her own salon. "At my house . . . we met at about nine o'clock. No one ever talked politics, but we chatted about literature and told anecdotes of the hour. . . . At ten o'clock we sat down to table. My suppers were of the simplest. They always consisted of some fowl, a fish, a dish of vegetable, and a salad, so that if I succumbed to the temptation of keeping back some visitors, there really was nothing more for anyone to eat."

Elisabeth still hosted entertaining supper parties, and she recounted a night that became the talk of the town. Ancient Greek and Roman (also called classical) culture was all the rage in the court of Louis XVI. Earlier in the century, the ruins of Pompeii and Herculaneum had been discovered. These Roman cities had been hidden from the world since they were buried

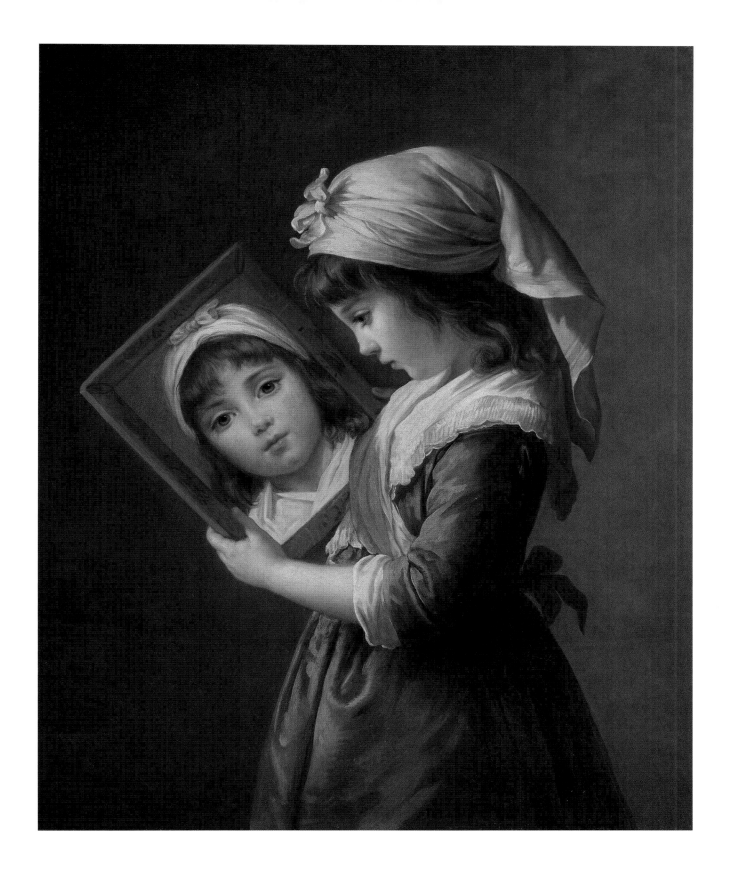

Viscountess of Vaudreuil, 1785

Victoire-Pauline de Riquet de Caraman raised her status in society by marrying Jean-Louis, Viscount of Vaudreuil, in 1781. This three-quarter-length portrait depicts the young viscountess wearing a fashionable version of a *bergère* hat over loose powdered hair, a silk dress, and a gauze scarf; an organza ruff and cuffs protrude from her dress. Her right thumb holds her place in a book that she is halfway through reading.

The Age of Enlightenment

A revolution in human thought in the 1600s and 1700s in Europe, the Enlightenment (also known as the Age of Reason) emphasized the individual and the importance of reason instead of superstition and religious fanaticism. The leaders of the movement in France were called the Philosophes. Montesquieu, Jean-Jacques Rousseau, and Voltaire produced books, essays, and plays that they believed would improve the world by encouraging people to think for themselves instead of trusting the French government and the Catholic Church. Enlightenment topics were discussed in salons, working spaces that were run by self-educated women. The salons were not the same as dinner parties; they were opportunities for the host and her guests to learn about and help shape Enlightenment ideas. Participating in a salon helped provide a formal education for women who were not permitted the same education that men enjoyed. Men of letters, philosophers, and scientists would read aloud extracts from their cutting-edge work to the invited guests, who were prepared to engage in intelligent conversation on the topic of the evening.

under volcanic ash by the eruption of Mount Vesuvius in 79 CE. As houses, wall paintings, sculpture, and furniture were excavated in the 1700s, they inspired widely circulated illustrations of a lost world. Styles based on ancient Greece and Rome flourished, especially in architecture and furniture design.

One day in 1788, Elisabeth had invited twelve to fifteen guests to a poetry recital at her home. Her brother, Etienne, arrived early and read a book to Elisabeth while she was resting. When he came to a description of a Greek dinner, complete with recipes, the siblings instantly decided to improvise a similar dinner that very night. Elisabeth's cook agreed to prepare two special sauces for the poultry and seafood and a cake made with honey and raisins. Wine from Cyprus was served from a genuine Etruscan vase brought over by a neighbor. Using fabric she kept in her art studio, the creative hostess assembled classical costumes *à la grecque* (in the Greek style). The women wore white tunics and Elisabeth wore a crown of flowers, and she helped little Julie to dress up, too. The men were given laurel wreaths to put on their heads, and Elisabeth found a purple cape for the visiting poet, who performed lyric verse by the Greek poet Anacreon. Elisabeth and her friends had a wonderful time at her spontaneous toga party, though she would pay a price for it later.

Reversal of Fortune

Marie Antoinette, once widely admired for her elegance and style, was now more often attacked for it. France was changing, and times were hard. High unemployment rates, increased taxes, and rising food prices weighed heavily on the poor, and resentment of the rich and royal was growing. Already established as an icon of wealth and privilege, and still regarded by many French citizens as a foreign interloper in France, the queen was an easy target for critics of the monarchy. She was accused of everything from sexual misconduct to aggressive behavior unbecoming of women, who were expected to remain overshadowed by their husbands and compliant with society's rules. She was denounced for her extravagant spending on clothing and jewels—and then reproached when she tried to wear more informal attire. (One unspoken reason: as the fashion icon of France, any change in her style—say, from French silk to Austrian linen or Indian cotton—might be widely imitated and thus impact the economy.) This reputation for excess helped to spread false reports about the queen's alleged participation in a criminal plot to defraud the crown jewelers and acquire an expensive diamond necklace. The so-called Affair of the Diamond Necklace became a political lightning rod in 1785 and 1786, with Marie Antoinette (who was innocent of the accusations) as the public symbol of the monarchy's disgrace.

With the reputation of the queen under attack, King Louis XVI commissioned Elisabeth to paint a large portrait of Marie Antoinette with her

children that would convey a family-friendly image. Elisabeth depicted Marie Antoinette as a Madonna, a good mother, who served the state by providing not just one but two male heirs to the throne. The work also shows the queen's daughter and an empty cradle as a reminder of a baby girl who died while the family portrait was being completed. To create the painting, intended to bring the royal family back into the public's favor, Elisabeth relied on her extensive knowledge of important European paintings, specifically Renaissance works showing the Holy Family. She took nearly two years to finish it, and it was displayed in the Paris Salon in August 1787. It was a masterwork, but one whose message went unheeded. Marie Antoinette could no longer defend her reputation or be defended. It wasn't enough to be the mother of future kings when the whole concept of inherited monarchy was under attack.

Elisabeth's close connection to the queen and her own position as a social luminary had made her a target of vicious gossip as well. After her guests told their friends about her Greek dinner, the story spread far and wide and morphed into a disparaging tale of frivolity and excess, with the alleged cost of the evening multiplied with every telling. Another rumor held that a particular male artist had secretly painted all of Elisabeth's portraits for her, since of course no woman really could be that talented. Elisabeth scoffed at this claim, noting "the fact that the people who sat for me could stand as witness to the contrary." One persistent rumor involved Charles Alexandre de Calonne, controller general of finance to the king. Wrote Elisabeth, "There were a thousand unkind rumors about me, but one I found particularly wounding. . . . I have been plagued with slanderers who conspired to accuse me of having enjoyed an intimate relationship with Mr. de Calonne." Elisabeth painted Charles's portrait in 1784, and the wedding of her brother, Etienne, was held at his home. Elisabeth devoted several pages of her memoir to refuting this rumor, which she claimed began when she loaned her carriage to a charming female client who parked it overnight at the Ministry of Finance. She further defended her honor by pointing out that Charles wore wigs, which she couldn't stand. Whether true or false, this type of gossip might not have affected the career of a male painter, but it certainly held the power to crush a woman artist's reputation. The never-ending gossip was "enough to make one lose all taste for fame, especially when one is unfortunate enough to be a woman," Elisabeth wrote. "Indeed, in whatever field it may be, doesn't fame always incite envy? Though it's true that it also attracts your most distinguished contemporaries, and this provides consolation for many things. When I think of so many good and likeable people who have appreciated my talent, I congratulate myself for making a name for myself."

The swirling gossip did not stop Elisabeth from painting, or even from daring to provoke the art establishment. In a self-portrait with Julie, she

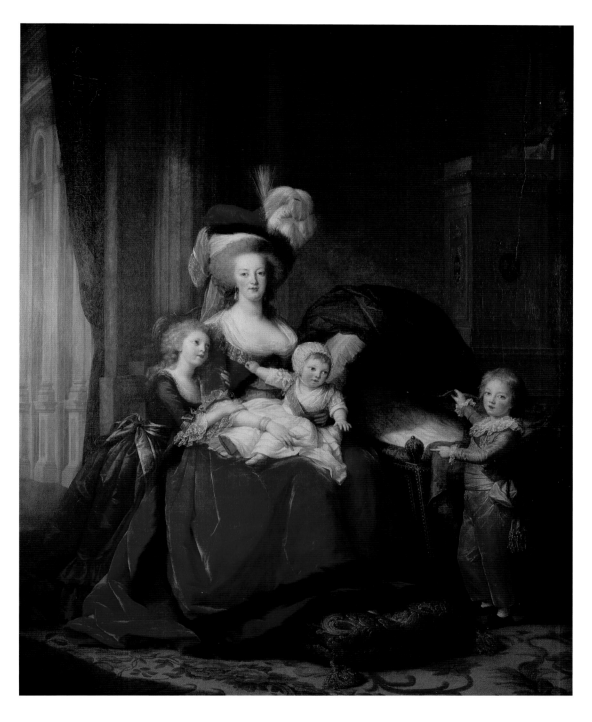

***Marie Antoinette and Her Children,* 1787**

This family portrait is based on a formula from religious paintings depicting the Virgin Mary in Majesty. The queen cradles Louis-Charles, who would later become crown prince after the death of his older brother in 1795. Marie Thérèse Charlotte, the future Duchess of Angoulême, leans into her mother, while the eldest son, Louis Joseph Xavier François, points to the empty bassinet of another child, Sophie Hélène Béatrix, who died in infancy.

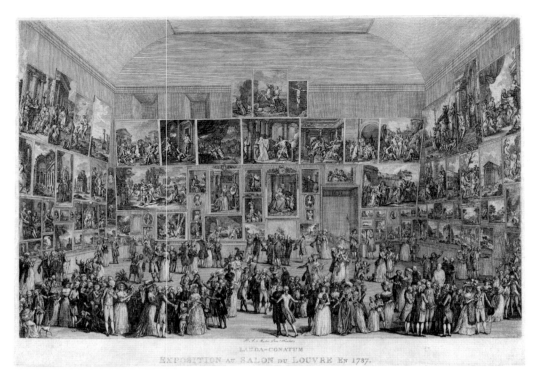

Paris Salon of 1787, etching by Pietro Antonio Martini after a painting by Johann Heinrich Ramberg

This depiction of the Paris Salon not only records the works on display but also captures how these exhibitions looked. Paintings are hung floor to ceiling according to the importance of the artist and the subject. In the center of the back wall, Elisabeth's portrait of Marie Antoinette hangs in a prominent position. This engraving also brings to life— with a good sense of humor— how people behaved at these exhibitions. Men, women, children, and at least one dog mingle; two boys reach for a book on the floor. Like many art openings today, the Paris Salon was as much a social event as a showcase of art.

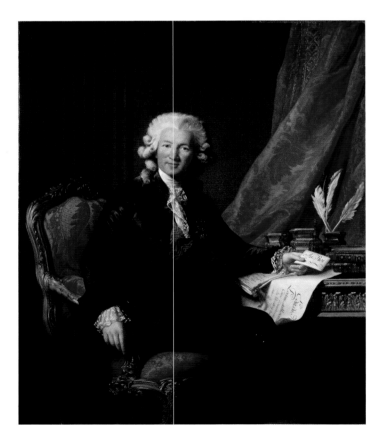

Charles Alexandre de Calonne, 1784

Charles worked for Louis XVI as controller general of finances. The letter in his left hand is addressed *au roi* (to the king). He was given the unenviable task of solving France's financial problems. Though he came up with an ambitious plan, he was unable to get government support for his reforms. In this portrait, Elisabeth shows Charles at his ornate desk decorated with gold leaf wearing luxurious clothes that signify his wealth and status. The painter skillfully depicts light reflecting from his waistcoat. Around his neck he wears a cravat, a soft necktie made from lace. Quill pens such as the four visible on his desk were delicate and difficult to use. Charles would have had to dip them frequently in ink, risking stains on the elegant lace ruffles edging his cuffs.

portrayed mother and daughter wearing classically inspired tunics and loose hair. The painting is an expression of maternal love, emphasized by Elisabeth's smiling and open mouth. When it was displayed at the Paris Salon, critics condemned the work, specifically pointing out the transgression of the artist showing her teeth. Keenly aware of the power of portraits to influence public opinion, Elisabeth understood the repercussions of exhibiting such a daring portrayal of herself. To strike a pose was to challenge prevailing ideas about gender and conformity.

Another unconventional work was Elisabeth's powerful full-length portrait of Muhammad Dervish Khan, an Indian ambassador to France. In 1788 Tipu Sultan, the ruler of Mysore in India, sent three ambassadors to meet Louis XVI. They hoped to enlist the French king's help in resisting English aggression. The sensational arrival and subsequent stay of these emissaries in Paris was reported on daily. They were welcomed at court, treated to plays and operas, and toured porcelain, silk, and wallpaper factories. Elisabeth recognized this visit as a rare opportunity to portray people who were different from the French aristocrats she typically painted. The ambassadors did not immediately consent to Elisabeth's request to paint them, but they agreed after the king himself intervened. Nobody knows what these Muslim men thought about a woman painting them, although it must have been a strange experience, as women in Mysore were secluded from men. As Elisabeth recounted, "I went to the townhouse in which they resided (because they wanted to be painted there) with my large canvases and colors. When I arrived in their living room, one of them brought some rosewater and sprinkled it on my hands. Then the taller of the two, whose name was Dervish Khan, sat for me. I painted him full length, holding his sword. The draperies, the hands, everything was as he wished it to be, so obligingly did he pose."

Ultimately, the ambassadors' ill-timed mission was a failure. With rising discontent in France, the king was in no position to offer assistance to Mysore. The combined pressures of economic inequality, political oppression, and a desire for democratic rights were moving the populace toward a revolution, which would lead to the violent downfall of the monarchy and the spread of democratic ideas across Europe. In July 1789 a crowd of citizens stormed the Bastille, a medieval fortress that was being used as a prison. This early victory became an important symbol for the revolutionaries' cause.

Time to Go

Elisabeth was frightened of the increasing violence and instability, "constantly anxious and deeply pained," and she began thinking about leaving France. One night, a mob of national guardsmen carrying weapons barged into her home. According to her account of that terrifying night, most of the men were

Self-Portrait with Julie, 1789

This self-portrait conveys
Elisabeth's deep affection for her
daughter. Typical of the artist,
Elisabeth imaginatively drapes
herself and Julie in classical
tunics, hers belted with a bright
red scarf.

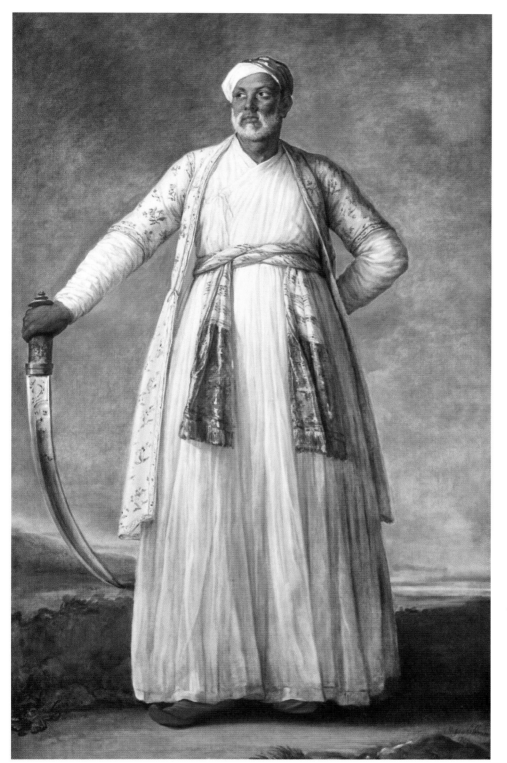

Muhammad Dervish Khan, 1788

Elisabeth clearly delights in depicting the texture of Muhammad Dervish Khan's gauzy white muslin gown, gold embroidered sash, and floral overcoat. In the Indian ambassador's right hand is a sword inlaid with gold and gemstones, which, while intimidating, was meant not for battle but merely as a ceremonial representation of power and wealth.

drunk, shabbily dressed, and frightening to behold. They told her she would not be allowed to leave the country. After the group went away, two of its members returned to warn her: "We are your neighbors; we have come to urge you to flee as quickly as possible." They said she should not take her own carriage but a public one; she purchased the first stagecoach tickets she could get.

France had become a perilous place, and as a monarchist, an antirevolutionary, and a close ally of the queen, Elisabeth had good reason to fear for her life. Pierre, in contrast, had become an ardent revolutionary and a supporter of Maximilien Robespierre, a progressive lawyer and statesman who advocated for democracy; however, as Elisabeth's husband, Pierre still felt threatened. Nevertheless, he decided to stay in France to protect his art collection and his business. He helped his wife and daughter arrange their departure from Paris, out of concern for their safety. It seems likely that at this point Elisabeth and Pierre—who lived in separate apartments within the same house—had merely a marriage of personal and professional convenience, possibly somewhat fractured by their opposing political stances. Divorce was still prohibited by the Roman Catholic Church at that time, so they would not have considered it.

Many of Elisabeth's aristocratic clients, including the Duchess of Polignac, had already left the country to seek safety elsewhere in Europe. Rosalie Bocquet Filleul, Elisabeth's childhood friend, chose to remain in France. Elisabeth recalled, "Alas! I remember that as I was about to leave France, to flee the horrors that I foresaw, Mrs. Filleul said, 'You are wrong to leave. As for myself, I am staying, for I believe in the happiness the Revolution is to bring us.'"

On October 5, 1789, thousands of women wielding pikes and pitchforks marched toward the Hôtel de Ville (the city hall) to protest the rising price of flour and their inability to feed their families. The march built momentum, with men joining in. The rallying cry "to Versailles" launched a fourteen-mile march from Paris to the palace of Versailles, with protesters carrying knives and picks and dragging cannons. Even with his troops, the young Marquis de Lafayette (a French hero in the American Revolution) could not stop the flood of angry civilians who pushed through the palace gates. The crowd stayed the night, demanding that the king and queen make a public appearance. They finally did, and a deal was brokered guaranteeing the safety of the royal family if they came to Paris. They would never return to Versailles.

On October 6, at midnight, Elisabeth and her daughter, along with Julie's governess, fled Paris in a shared coach. Elisabeth dreaded crossing the Saint-Antoine neighborhood, a center of revolutionary turmoil located near the Bastille tower. "I was extremely afraid of faubourg Saint-Antoine, which I would have to cross to reach the Trône border. My brother, the good Robert, and my husband protected the stagecoach door until I reached the gateway." Elisabeth carried a bit of money and little else, but she did have a vast network

of aristocratic connections she could rely on throughout Europe. Her contacts would prove to be lifesaving as she fled Paris for Lyon and then headed toward the Alps and onward to Italy.

Elisabeth would later learn that her great patron, Marie Antoinette, was publicly executed in 1793, reviled as a symbol of the fallen monarchy.

Of Rosalie Bocquet Filleul, Elisabeth lamented, "How can I talk about this loveable woman without recalling the tragic end of her life?... this Revolution took her to the scaffold. She had no sooner left the Château de la Muette than that period so justly named The Terror arrived. Mrs. Chalgrin, the daughter of Joseph Vernet and the close friend of Mrs. Filleul, came to this chateau to celebrate the wedding of her daughter without much fuss, you can be sure. However, the very next day, the revolutionaries came to arrest Mrs. Filleul and Mrs. Chalgrin, who were said to have 'burned the candles of the nation.'"

Candles were precious and considered a national resource; this accusation was a way of saying that the women had been extravagant at the nation's expense. Both were found guilty and condemned to death by guillotine in 1794.

3
On the Run

Elisabeth's dramatic escape from Paris via stagecoach on October 6, 1789, was an emotional turning point in her life. Not only did she leave her husband, mother, and brother behind, but her network of friends and clients had unraveled, since most of them were associated with the royal family. The fear and upheaval she felt, along with concern for her nine-year-old daughter, were probably shared by Mrs. Charot, Julie's governess, who parted with her own family and friends under the same fraught circumstances. Only occasionally did Elisabeth mention the governess in her memoir; perhaps Elisabeth thought the mundane conversations between these two women, who would travel together for years, would be uninteresting to her readers.

When the coach stopped at an inn for dinner, en route to the first night's stay in Lyon, crowds of people surrounded the travelers, anxious for news about the Revolution. Before the invention of electronic communications such as the telegraph, information traveled slowly and erratically, typically by mail coach. At the time of the Revolution, almost four-fifths of France's population lived in rural areas, far from the historic events unfolding in the capital city.

Travels of Elisabeth Louise Vigée Le Brun

- ———— 1781
- ———— 1789–92
- ———— 1795
- ———— 1800–1801
- ———— 1801–2
- ———— 1803–5
- ———— 1807
- ———— 1808
- ———— 1820

Bath

London

Brighton Dover

The Hague
Amsterdam
Maassluis
Antwerp
Brussels

Calais

Rheinsberg
Brunswick Potsdam
Berlin

Gotha
Weimar Dresden

Frankfurt

Prague

Louveciennes Paris

Orléans
Tours Blois

Bordeaux

Zürich

Geneva

Lyon

Chambéry

Turin

Milan Verona
Mantua
Parma
Modena

Vicenza
Venice
Padua

Bologna

Florence
Siena

Arezzo

Perugia

Rome

Naples

Vienna

Memel
(Klaipeda)

Königsberg
(Kaliningrad)

Riga

Mitau
(Jelgava)

Narva

Saint Petersburg

Veliky Novgorod

Moscow

0 500 km

0 500 mi

Schaffhausen

Biel/Bienne
Neuchâtel

La Broye

Solothurn
Bern

Zug
Lucerne

Zürich
Erlenbach

Walenstadt

Goldau
Schwyz

Thun
Interlaken
Lauterbrunnen

Coppet
Geneva

Vevey

Chamonix

**Map Showing the Travels of Elisabeth
Vigée Le Brun from 1781 to 1820**

This map shows the extensive journeys
that Elisabeth made over the course
of her adult life, beginning in 1781, when
she left Paris for the first time on a trip
to Holland and Flanders with Pierre, and
ending with her final trip to Bordeaux.

Elisabeth had acquaintances in Lyon, but she claimed they didn't recognize her because her physical appearance had changed so much, and her clothing resembled that of a poorly dressed laborer. Of her departure from Lyon days later, when she crossed the border into Italy, she wrote, "I cannot tell you what I felt on crossing the Beauvoisin Bridge. Only there did I start to breathe. I was out of France, but France was still my country and I felt guilty for leaving it with such a feeling of joy."

Elisabeth, Julie, and Mrs. Charot spent the next three years traveling through Italy before proceeding to Austria, Germany, and Russia. A map showing Elisabeth's routes throughout her lifetime, on which she often traveled by horse-drawn coach, might seem ambitious even in today's age of planes and trains. In the 1700s transport across Europe was slow, rough, and dangerous, and one can only imagine how the little group passed the time, sitting on a plank in a shared carriage, jostling back and forth as they journeyed through wild terrain that rarely saw outsiders. Elisabeth recalled the misery of riding with unsavory carriage mates on rutted roads, finding no dinner at the end of a long day's ride, and endlessly searching for clean and quiet lodging. She related encounters with individuals who assisted her in smaller cities such as Turin, Parma, and Bologna, where they stopped on the way to the major urban centers of Florence, Rome, and Naples. For example, she remembered pulling into an inn late at night in Turin, only to discover that the kitchen was closed. Elisabeth, Julie, and Mrs. Charot went to bed hungry. The next day, an artist named Carlo Antonio Porporati, whom Elisabeth had met a few times in Paris, came to the inn. Finding her poorly rested and in need of a good meal, he insisted that the three women stay with him during their few days in Turin. Such moments, when mere acquaintances bent over backward to take care of Elisabeth, pepper her memoir, as she remained forever grateful for such gestures of kindness.

Live and Learn

She had left France under duress, but Elisabeth was not going to waste the unexpected opportunity to pursue her artistic education in Italy, home to many of history's most important painters. In each city, she made a beeline to view the famous paintings she would have known about only through black-and-white prints or written descriptions. Her fame granted her access to private galleries, and she was often guided around cities by aristocratic expatriates and the directors of prominent art academies. News of her entourage traveled quickly; only three days after arriving in Bologna, she was admitted as a member of that city's Academy of Fine Arts. When she reached Florence, Leopoldo, Grand Duke of Tuscany, invited Elisabeth almost immediately to create a self-portrait for his gallery in the Uffizi, where she could claim her

A Role Model in Rome

In her memoir Elisabeth mentioned Angelica Kauffmann a number of times as a woman who had comfortably established herself alongside male artists. She admired Angelica's wit and knowledge, and she felt inferior to the older artist, who had mingled as a good friend with prominent men of letters and the arts. Angelica had moved from England to Rome with her second husband, the artist Antonio Zucchi. As one of the highlights of her later years, Angelica painted a self-portrait in 1787 at the request of Leopoldo, Grand Duke of Tuscany. She wrote to her friend the poet Johann Wolfgang von Goethe that the painting had been graciously accepted and placed "in a very good light and next to a formidable man, none other than Michelangelo Buonarroti." For her work, Angelica received a large gold medal. In this self-portrait, she depicts herself casually holding the instruments of her profession.

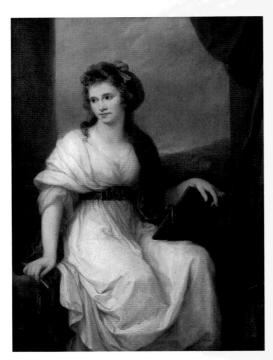

Self-Portrait by Angelica Kaufman, 1787

Self-Portrait, 1790

In this work for the Uffizi Gallery, the edge of the canvas leaning on an easel provides the only hint at perspectival depth in the composition. Elisabeth's face is framed by a magnificent white-lace collar and muslin turban that shine against the dark background. Her parted lips recall the earlier self-portrait with Julie that scandalized the Parisian art world. There, the artist's slightly opened mouth, conveying a sense of ease, was viewed as vulgar. No such criticism arose when Elisabeth publicly presented this self-portrait in Italy; instead the painting was admired and secured her a place in the Academy of San Luca in Rome.

place in an artistic lineage of famous painters. Only one other woman artist had been given the same honor, the Swiss-born painter Angelica Kauffmann, whom Elisabeth would later make a point of visiting in Rome.

Arriving in that city in mid-November 1789, Elisabeth recalled the challenges of finding a suitable place to live in Rome: "At last I found a house that seemed to fill all my requirements. I had hardly gone to bed when I heard a maddening noise. It was caused by a multitude of worms crunching beams. . . . As soon as I opened the shutters, the noise stopped. Still, I regretfully vacated this house, having already moved incessantly." She eventually settled into Roman life and began working on her self-portrait for the Uffizi. Elisabeth took a different approach from that of Angelica, depicting herself in the act of painting a portrait of Marie Antoinette, her beloved patron and the youngest sister of Leopoldo, who would later become Holy Roman Emperor Leopold II.

Elisabeth enjoyed Rome for its art, its music—she was especially fond of opera—and its importance as the seat of the Catholic Church. She reminisced about an Easter day when she joined the crowds in Saint Peter's Square to be blessed by Pope Pius VI, who was splendidly dressed all in white. The evening spectacle included brilliant illumination of the dome of Saint Peter's Basilica and fireworks above the Castel Sant'Angelo. She wrote, "The satisfaction of living in Rome helped ease the pain of leaving my country, my family, and

so many friends I cherished. Artists find inspiration in beautiful places that infuse a little sweetness into one's life."

There were many other French exiles in Rome, and soon Elisabeth made a close friend, Aimée de Coigny, the Duchess of Fleury. "We felt naturally drawn to each other. She loved the arts and, like me, was passionate about nature's beauty. At long last, I found in her the sort of friend I had often imagined." Aimée and Elisabeth spent many evenings at the lively dinner table of Prince Camille de Rohan, who enjoyed hosting distinguished international guests. The two women took day trips to view ancient ruins, and they rented a summer house together in Genazzano, where Julie and her governess accompanied them. "As soon as we had settled into our house, our excursions into the surrounding area began. We hired three donkeys, for my daughter always wanted to join the group." Like all artists, Elisabeth trained her eye by constantly sketching. She found it impossible to walk around without feeling compelled to pick up her pencils: "I have never been able to take a little trip, not even a walk, without bringing back some sketches."

Her decision to travel south to Naples seems related to warmer weather and the promise of high-paying work. As she had since her father's death, Elisabeth needed to make a living. Aimée would leave Italy before her, staying in London before returning to Paris in 1793. There she divorced the Duke of Fleury, to whom she had been married at age fifteen. She was briefly imprisoned in 1794 by the Revolution but was soon freed to follow her own path.

The Italian Puzzle

In 1790 Italy was not unified under a single government as it is today; instead, it resembled a puzzle, with each piece ruled by a different kingdom—or, in the case of the Papal States, by the pope. Many people spoke dialects specific to their regions, further fragmenting the population. A common language can help to unify a country, instill a sense of national identity, and promote equality and democracy. No wonder the ruling classes of the numerous kingdoms and papacies throughout the Italian peninsula wanted to preserve their separateness; they felt threatened by the ideas of liberty, equality, and national pride symbolized by the French Revolution. Writers, historians, and artists were beginning to embrace the idea of Italy as a singular cultural and historical place, and the French Revolution conveyed related ideas about a central democratic government. Eventually, on March 1, 1861, inspired by the transformations of the United States and France, Italy celebrated its official unification.

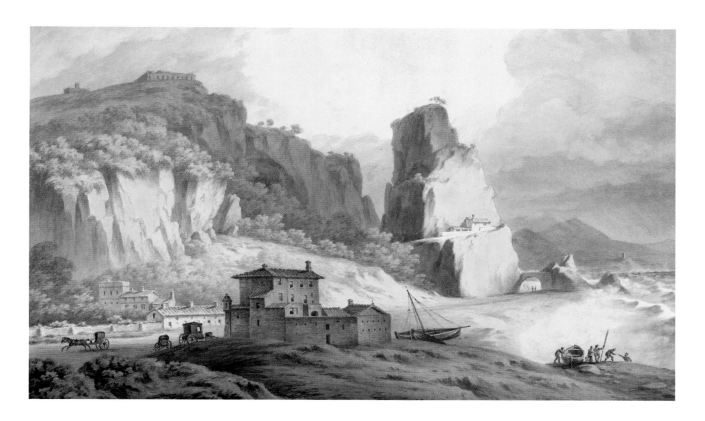

In April 1790 Elisabeth took a carriage with Julie and Mrs. Charot on a 140-mile journey with one overnight stop in Terracina, a town surrounded by marshes. Both Elisabeth and Julie were taken by the extraordinary beauty of the watery land and the vast ocean beyond, which an awestruck Julie described as "larger than life."

In her memoir Elisabeth mentioned Julie from time to time, taking note of her young daughter's poetic comments about her unfamiliar surroundings. For example, in the hills surrounding Florence, Julie said of the cypresses: "the trees invited silence." Elisabeth took pride in Julie's early accomplishments, especially her interests in painting and in writing fiction. Elisabeth remembered, "Returning from an evening with my friends, I would find her with a quill in one hand and another in her bonnet. I put her to bed, but it was not unusual for her to get up during the night in order to finish a chapter, and I remember well that by the age of nine she had written a short novel, remarkable for both its story and its style." Julie was afforded an unusual education for any child, let alone a girl, in the 1700s. "I had resolved, while traveling the world, to take care of her education as much as possible." Elisabeth provided Julie with tutors in writing, geography, Italian, English, and German and commented that Julie showed "remarkable intelligence in her various studies." Julie's secular curriculum starkly contrasted with her mother's Catholic school experience.

A View of Terracina on the Coast between Rome and Naples by John Warwick Smith, late 1700s

This detailed watercolor depicts a typical Italian coastal scene with a fishing boat heading out to or coming back from the sea. Although idealized, this picture captures the essence of the many small towns that dotted the Italian coastline, isolated by the jagged mountains.

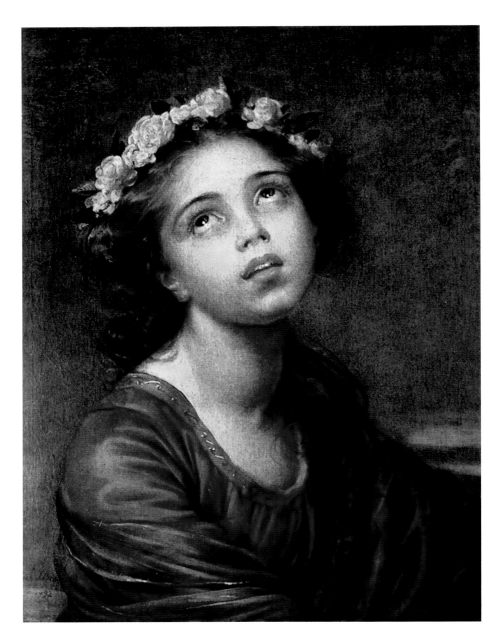

Daughter Julie, 1792

In this half-length portrait, Julie looks skyward with her lips parted, as if gazing toward the heavens. A delicate wreath of pink flowers and green leaves encircles her head, her wavy hair tumbling casually down her left shoulder. This painting resembles a portrait of Julie that Elisabeth submitted as a thank-you to the Academy of Fine Arts in Bologna in 1789 for electing her as a member.

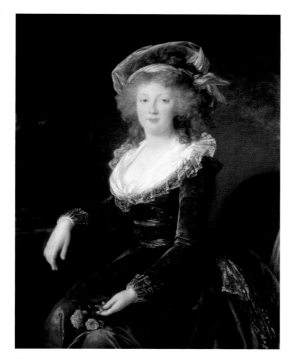

Maria Theresa, Later Empress of Austria, **1790**

Maria Theresa was the eldest child of Ferdinand IV and Maria Carolina. In 1790 she married her first cousin, Archduke Francis of Austria, who in 1792 would become the last Holy Roman emperor and in 1804 the founder and first emperor of Austria.

Maria Luisa Amelia, Later Grand Duchess of Tuscany, **1790**

Maria Luisa Amelia Teresa was the second child of Ferdinand IV and Maria Carolina. In 1790 she married her cousin Archduke Ferdinand of Austria. In Elisabeth's estimation, Maria Luisa was unattractive and so affected that she did not want to paint her portrait.

Courting a New Court

In Naples, Elisabeth once again activated her charm and glamour to cultivate a new social circle of royals and aristocrats. At the time of the artist's arrival, Naples was an independent kingdom under the rule of Ferdinand IV, a member of the Spanish line of the House of Bourbon. He was married to the Habsburg princess Maria Carolina, a sister of Marie Antoinette. Like her famous younger sister, Maria Carolina had been betrothed in her early teens, assuming the obligation to perpetuate the royal Habsburg dynasty and serve as a political diplomat. Maria Carolina was vocal about her unhappiness but fulfilled her duty by bearing eighteen children, seven of whom lived to adulthood. Ferdinand, who had a spotty education and preferred sports and hunting to his duties, left a power vacuum that his wife quickly filled. She played a highly visible role as queen, using the throne to alter the course of Naples with her firm grasp on government and court life. She detested the Revolution in France and stifled reformers, intellectuals, and secular movements in Naples, allowing the Church greater power to mute revolutionary ideas. At the same

Maria Carolina, Queen of Naples, 1791

Elisabeth's original portrait of Maria Carolina was destroyed in a fire in 1940; this is one of a number of copies painted in the late 1700s. The details Elisabeth included in her portraits allowed a knowledgeable viewer to appreciate the person's place in society. In her lap Maria Carolina holds a book embossed with her coat of arms, representing the royal houses of Habsburg and Bourbon. Elisabeth's depiction of Maria Carolina intentionally resembles an earlier portrait of Marie Antoinette (see p. 61).

time, she offered assistance to émigrés fleeing revolutionary France.

Given Elisabeth's connection to Marie Antoinette, it is not surprising that among the artist's very first commissions in Naples were portraits of Maria Carolina's children, followed by a portrait of the queen herself. "The French ambassador, Baron Talleyrand, presented himself one morning to announce that the queen wished me to paint her two older daughters, which I began immediately. Her Majesty was preparing to leave for Vienna, where she would set about making arrangements to marry off these princesses. I remember her saying to me upon her return: 'It was a happy voyage: I've just negotiated two marriages for my daughters, much to my satisfaction.'"

As always, Elisabeth pursued every opportunity to experience the world around her. She climbed Mount Vesuvius, the still-active volcano that had buried Pompeii in ash in 79 CE. She visited the ruins of the Temple of Juno at Paestum, the islands of Ischia and Procida, and the museum in Portici. She wrote, "These excursions, and many others, did not prevent me from working hard in Naples. I had undertaken so many portraits that my first stay in this city lasted for six months, although my intention had been to stay only six weeks."

Queen Maria Carolina found Elisabeth enchanting, and she tried to convince her to stay in Naples by offering her lodging by the sea. But the artist longed to return to Rome. She had become tired and also despondent, waiting fruitlessly for good news and a glimmer of hope that she might be able to return to Paris, but that would not come for a long time.

For the next year, the trio lived in Rome, where Elisabeth painted, in her opinion, one of her finest works: *Emma Hart, Later Lady Hamilton, as the Cumaean Sibyl*. Emma had twice previously posed for Elisabeth, who painted her in 1790 as Ariadne, a princess in Greek mythology, and as a bacchante, a devotee of the Greek god of wine. Emma was the daughter of a blacksmith in a rural area of England and had no formal education, but she was a talented

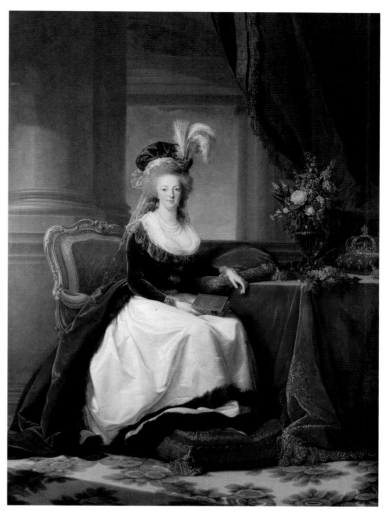

Marie Antoinette in a Blue Velvet Dress and a White Skirt, 1788

Elisabeth based her portrait of Maria Carolina on this painting of Marie Antoinette, who takes the same position and wears a similar blue cloak over a satin dress. Her look is completed with drop pearl earrings, pearl necklaces, and a hat with a pouf and ostrich feathers. Elisabeth ties together the two sisters through these details as well as the undeniable family resemblance.

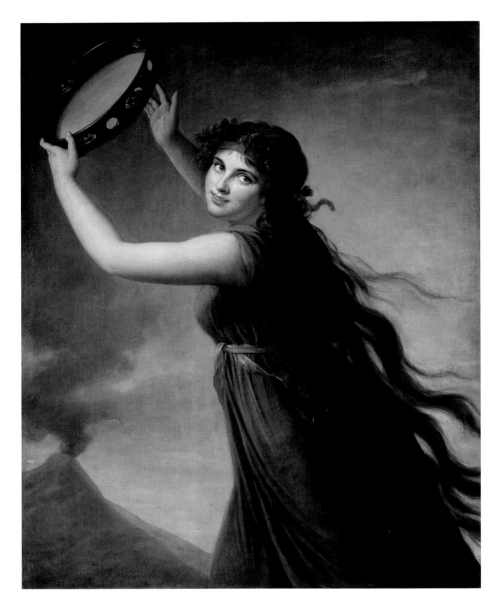

Emma had a penchant for the dramatic, which Elisabeth alludes to in this vibrant portrait with a smoking Mount Vesuvius in the background. Notorious for her public performances, Emma draped herself in veils and shawls, posing as figures she had seen on the ancient vases that her husband collected. During her stay in Naples, Elisabeth painted Emma four times. Elisabeth never sold or gave away this painting, which her niece inherited upon her aunt's death.

Who Was the Cumaean Sibyl?

According to legend, the Cumaean Sibyl was a priestess of the god Apollo. She told the future in the form of prophecies and was named after Cumae, an ancient Greek colony that once existed near Naples. One of twelve sibyls, she was said to have predicted that Christ would be born to a virgin mother in a stable at Bethlehem. The Cumaean Sibyl is referred to several times in classical literature, including in Ovid's *Metamorphoses* and Virgil's *Aeneid*. Beginning in the 1400s, Italian painters typically depicted sibyls holding books or scrolls. Most famously, Michelangelo painted the Cumaean Sibyl on the ceiling of the Sistine Chapel. Elisabeth specifically mentioned seeing the painter Guercino's depiction of the Cumaean Sibyl while she was in Bologna.

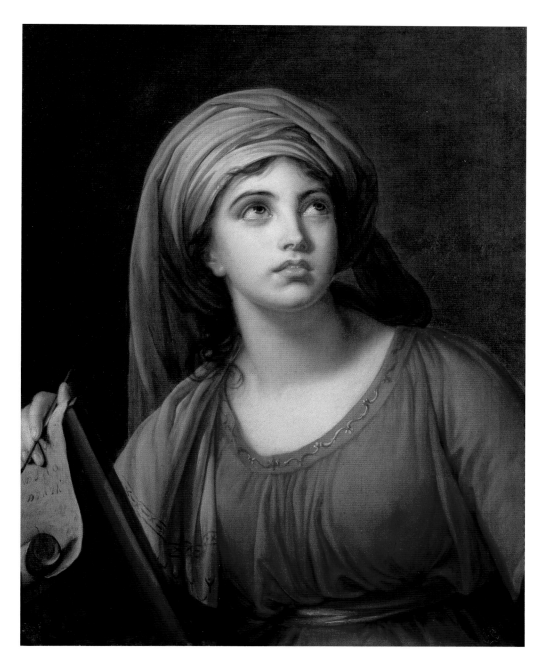

Emma Hart, Later Lady Hamilton, as the Cumaean Sibyl, 1792

Some confusion surrounds the two versions of this work. This one is signed "L.E. Vigee Le Brun/a Rome 1792," indicating that the artist took this painting with her when she left Naples. It is possible that Elisabeth kept this work because it met with such acclaim that she saw its value as a way to promote her artistic talent.

She produced a second, full-size version soon afterward, possibly to fulfill the original commission from the Duke of Brissac. By the time she completed the second version, the duke had been slain in a revolutionary massacre in September 1792.

The Eruption of Mount Vesuvius on August 9, 1779 by Pietro Fabris, 1779

Sir William Hamilton commissioned this hand-colored etching for his scientific account of an eruption of Mount Vesuvius for the Royal Society of London. William was an avid volcanologist who was as fascinated with Vesuvius as Elisabeth was. In the 1700s many people visited this otherworldly landscape to sketch and to collect rocks, shells, and antique fragments left in the paths of lava flows.

Great Balls of Fire!

The first time Elisabeth ventured up Mount Vesuvius, an active volcano, she was with her entourage, and they were caught in "a rain that looked like a deluge." She went on to say, "We were soaked, but we nevertheless walked up a hill to see one of the great lava flows at our feet. I thought I was touching the avenues of hell. An inferno that suffocated me snaked before my eyes; it was three miles in circumference. The bad weather prevented us from going farther that day, and smoke and raining ash covered us and made the top of the mountain invisible, so we climbed on our mules and descended into the fields of dried black lava. Two thunderclaps, that of the sky and that of the mountain, mingled; the noise was infernal, especially since it repeated itself in the cavities of the surrounding mountains. As we were precisely under the storm cloud, I was trembling, and our whole cavalcade trembled like me, fearing that the movement of our march should strike a thunderbolt on us." Far from being discouraged, Elisabeth returned to Vesuvius a few days later with Julie: "This time I took my little Brunette with me, as I wanted her to see this awesome sight."

singer, dancer, and actress. She rose from her working-class background to the ranks of high society through a series of romantic liaisons with—among others—Charles Greville, a prominent British politician. Her beauty captivated society painters such as George Romney and Sir Joshua Reynolds; the latter painted her repeatedly. In 1786 Emma and her mother traveled to Naples at the invitation of Sir William Hamilton, a British diplomat who served as special envoy to the court at Naples. Emma would marry William five years later, when she was twenty-six and he was sixty-one. An avid antiquarian, William would have appreciated seeing his fiancée depicted in the classical role of the sibyl.

Elisabeth, with her flair for the theatrical, quickly assembled the costume, wrapping Emma's head in a turban, one end of which she gracefully draped down the shoulder. Emma, for her part, did not disappoint: she had a natural ability to hold poses and expressions like a professional model. When the sitting was over and Emma had changed for dinner, into her more typical flamboyant style, the transformation rendered her unrecognizable to those who had seen her dressed as the sibyl.

Elisabeth prized this portrait so much that she made a copy for herself before departing Rome on April 14, 1792, and she would proudly display it throughout the rest of her travels. Instead of being introduced simply by name and reputation to people in unfamiliar cities, she presented the painting as evidence of her talents and quieted anyone who might question the authority she commanded as a woman artist.

False Hope

Elisabeth traveled north, intending to return to France. During a stop in Venice, she was asked by her friend Vivant Denon to paint a portrait of his lover, the celebrated writer Isabella Marini. Elisabeth kept up hope that the Revolution was nearly over and that she might soon return home. Without up-to-date news, she was unaware of the fate of the monarchy and her own status as an enemy of the state. That year, the revolutionary government had added her name to the "list of émigrés," which stripped her of her rights as a French citizen and gave notice to Pierre that all of the couple's property—including their home and Pierre's business and substantial art collection—would soon be confiscated.

Arriving in Turin, Elisabeth was shocked to see the results of the ongoing war in France. Thousands of French refugees crowded the city, desperate and hungry. When she received a letter from Auguste de Rivière, the brother of Etienne's wife, Suzanne, she learned the details of the events of August 10, 1792. Revolutionaries had invaded the Tuileries Palace in Paris, where the royal family was staying. When the attack was over, about six hundred palace

guards and two hundred revolutionaries had been slaughtered. The monarchy was finished, and within three days Louis XVI, Marie Antoinette, and their children had been imprisoned.

A few weeks later, Auguste himself fled France and arrived in Turin. Elisabeth wrote that upon seeing him, "I trembled as I asked for news of my mother and my brother, Mr. Le Brun and all my friends." He reassured her that her mother was safe in the town of Neuilly, that her husband, Pierre, was living quietly in Paris, and that Etienne and Suzanne were in hiding. Auguste would remain at Elisabeth's side for the next nine years. An artist and diplomat, he was good company for Elisabeth, who noted that "he had a sharp intellect, perfect tact, and such a noble heart." Sixty years old to her thirty-eight, he was elegant and slender, and, as Elisabeth described him, "he cut such a young figure in physique and demeanor, that at sixty, he could have been taken for half his age." Elisabeth admired Auguste's ability to act, sing, and play a variety of musical instruments. He was also a good painter who seems to have worked in tandem with Elisabeth, copying her portraits in miniature. She made two pastel portraits of Auguste that are now lost. It is tempting to speculate on the nature of the relationship, but Elisabeth, who was still a married woman, left few clues.

With the fall of the French monarchy, Elisabeth realized not only that she had to change her plans but also that her exile was going to be indefinite. An acquaintance in Milan urged her to go to Vienna, Austria, where he promised she would be warmly received. Taking this advice, Elisabeth, Julie, Auguste, and Mrs. Charot went together to the city of Marie Antoinette's birth. It was there that Elisabeth learned of her dearest patron's death by guillotine on October 16, 1793, at the age of thirty-seven. Before that event, Marie Antoinette's closest friend, the Princess of Lamballe, had refused to take an oath against the monarchy. She was turned over to a revolutionary mob who killed her and paraded her head on a pike outside the queen's window. Elisabeth understood that allies of the maligned and murdered queen remained in mortal danger—and that she could not return to Paris.

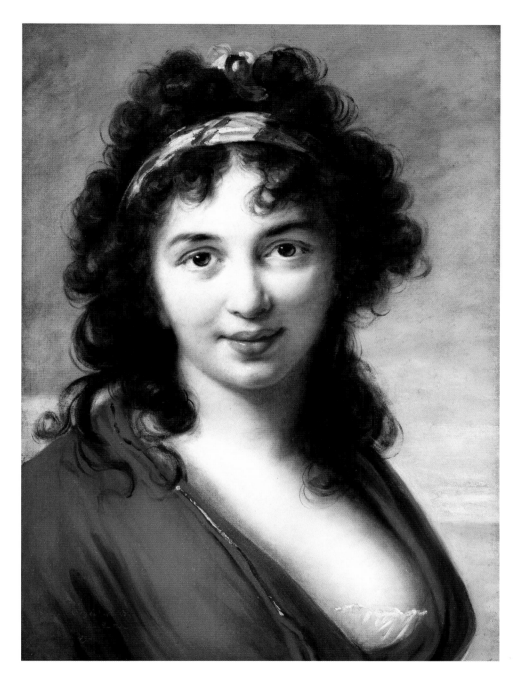

Isabella Teotochi Marini, 1792

In Venice, Elisabeth was introduced to Isabella Marini by the painter Vivant Denon. Though Isabella was married to the Count Giuseppe Albrizzi, she and Vivant were clearly more than just close friends. Vivant had met Isabella at the literary salon she hosted, one of the most famous and well attended by European artists, writers, ambassadors, scientists, and politicians. In Isabella, Elisabeth found a brilliant new friend. She painted this intimate portrait for Vivant, showing Isabella in a red dress embroidered with gold slips. Loose brown curls cascade over a cloth hair band. Elisabeth captures Isabella's outgoing personality as well as her looks, as she seems very natural and comfortable in her own skin.

4

Distant Empires

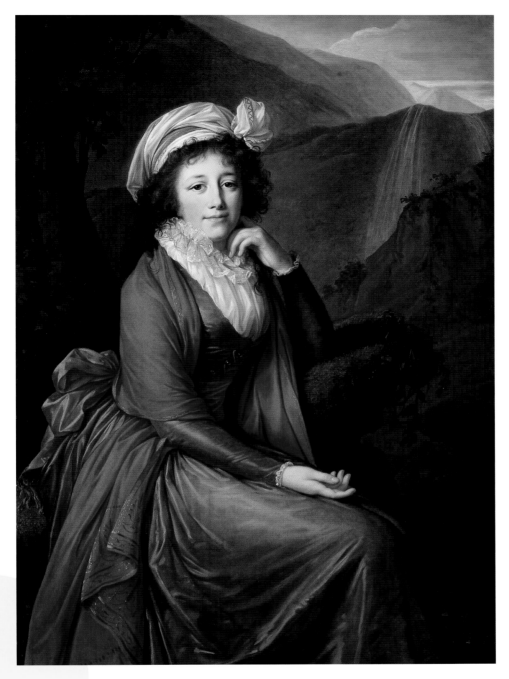

Countess Maria Theresia Bucquoi, 1793

Uncharacteristic of Elisabeth's usual style, this portrait places Maria Theresia in an outdoor scene: an imaginary combination of the mountains around the Danube River and the Marmore Falls, a waterfall built by the ancient Romans in Italy. Elisabeth had a great love for sitting outside and drawing landscapes as a personal hobby, but she did not produce landscape paintings for sale. The dramatic waterfall throws off a delicate spray with an iridescence that carries over into the sitter's shimmering dress—an effect that shows off the artist's skill. Elisabeth draped Maria Theresia in a large red stole embroidered with gold, an accessory the painter would use again and again in later portraits of Russian noblewomen.

"On the road to the Austrian capital, we passed through a part of the Tyrol. This road was both sublime and picturesque. There were majestic rocks embellished with lush vegetation and waterfalls, shining like crystal, which fed raging streams," wrote Elisabeth in her memoir. "At last we reached that splendid city, Vienna, where I would spend two and a half of the happiest years of my life."

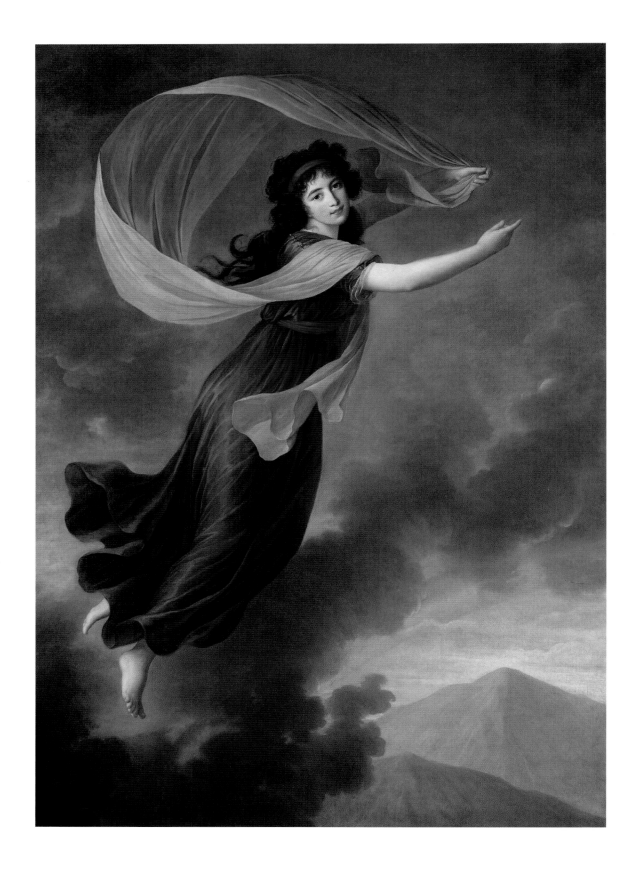

Elisabeth arrived with letters of recommendation that opened the doors to the most exclusive Viennese salons. And she had one of her finest portraits, the *Cumaean Sibyl*, to attract clients to her studio. "My *Sibyl* . . . had, I dare-say, much to do with persuading many people to commission portraits from me, so that I worked nonstop in Vienna. I would be hard put to express all my gratitude for the warm welcome I received in that city." The Prince of Kaunitz-Rietberg showcased Elisabeth's *Sibyl* for two weeks. Prince Wenzel Paar proudly exhibited Elisabeth's portrait of his sister, Countess Maria Theresia Bucquoi, painted with a stunning landscape in the background. Prince Alois I of Liechtenstein commissioned a portrait of his wife, Princess Karoline, whom Elisabeth chose to portray as Iris, Greek goddess of the rainbow.

Though she depended on portraiture to support herself and her daughter, Elisabeth clearly had a passion for natural scenery. She loved to watch light-ning storms from mountaintops and take walks in the moonlight. As on her daring ascents of Mount Vesuvius, she found inspiration and excitement in the awesome power of nature, and she was drawn to the beauty of mountain ranges, rivers, and valleys. In Vienna she often strolled alone or with Julie along the banks of the Danube River. During one such walk, she discovered "a superb group of trees, their color enriched by autumn's deep and varied hues, and . . . I could see the steep mountain of Kaltenberg in the distance. Charmed by this magnificent landscape, I settled myself on the bank, and taking up my pastels proceeded to draw."

As a woman, Elisabeth would have faced obstacles to a career as a land-scape painter like that of her revered mentor Joseph Vernet (who had died in Paris in December 1789, at the age of seventy-five). Most women artists were stuck indoors painting portraits; however, Elisabeth not only craved the outdoors but also wished to prove herself equal to men in her ability to paint landscapes and other kinds of scenes. Angelica Kauffmann, whom Elisabeth greatly admired, was one of few women artists she knew who had done it. Upon her departure from Rome, Elisabeth lamented, "I had regretted . . . not having used my time to paint scenes that inspired me. I had been elected a member of all the Italian academies and this encouraged me to try and merit such flattering distinctions . . . but so great was my need for money, having none of my French earnings, and so weak was my resolve, that I undertook commissions and drained myself painting portraits."

At this point, Elisabeth had come to terms with her situation. She rec-ognized that she was lucky to be alive, experiencing freedom and adventure beyond anything she could have imagined, and able to make a living as a famous artist, and so she didn't complain much. "I was as happy as I could be in Vienna while far from my family and homeland. In winter the town offered one of the most likeable and scintillating societies in Europe, and when the fine weather returned, I adjourned to my delightful country retreat." For

Princess Karoline von Liechtenstein as Iris, **1793**

Elisabeth had the chance to study many faces throughout her career. Princess Karoline's face, with its sweet and celestial expression, reminded Elisabeth of the mythological figure of Iris, divine messenger to the gods. Iris symbolized wisdom and valor, and she was associated with the rainbow, which she would slide down to visit Earth from Mount Olympus. Here, Elisabeth painted a rainbow in the far distance behind dark clouds that seem to carry Karo-line aloft. Her bare feet, daringly visible beneath the hem of her gown, may be a reference to Iris as "swift-footed" because of her travels between the heavens and earth.

Baroness Anna Stroganova,
1793

The same year she painted
Baron Grigory Stroganov,
Elisabeth created a companion
portrait of his wife, Baroness
Anna Stroganova. These paint-
ings would have hung side by
side so the couple's likenesses
could face each other. Anna is
shown arranging flowers in a
vase. A large pink ribbon holds
back her curly hair while she
smiles sweetly at the viewer.

three weeks, she, Julie, Auguste, and Mrs. Charot stayed in a remote convent on the Alpine mountain of Kaltenberg, where the cells, solitude, and clear mountain air delighted Elisabeth. "Mr. de Rivière, more of a city dweller than I, often ventured into town, but we nevertheless took lovely mountain walks. Sometimes my daughter would come and sit with me . . . and we would await the rising moon. I remember one evening, near her bedtime, she said to me, 'Maman, the moonlight makes you dream; it only makes me sleepy.'"

Nightlife in the city of Vienna was a different kind of dazzling. In addition to the attractions of music, opera, and theater, a new and daring dance had appeared at high-society balls: the waltz. At first people thought it quite scandalous, since men embraced their partners—even placing a hand on their waist—but the dance became hugely popular and remained so into the twentieth century. Wrote Elisabeth, "One could call them charming flings. People danced the waltz with such brio, whirling so dizzyingly, that I expected them to fall, but men and women needed no rest from this violent exercise, so accustomed are they to it." She had been eager to see a grand ball at the Viennese royal court, so she was delighted to be invited to one given by Emperor Francis II and his wife, Maria Theresa. Elisabeth had painted Maria Theresa in 1790 (p. 59) and thought her appearance had changed since then, unkindly commenting that it was a pity she now more closely resembled her father than her mother.

It was in Vienna that Elisabeth first met the Russian nobles Baron Grigory Stroganov and Baroness Anna Stroganova, amusing young acquaintances who were the toast of the town. "The baroness was loved for her sweet and kindly nature; as for her husband, he possessed a most superior talent for entertaining; he delighted Vienna by holding suppers, spectacles, and parties and everyone hoped they would be invited. . . . When [the baron] was in the mood to laugh and have fun, he would invent the most ludicrous schemes. On one occasion, knowing that several of his friends, myself included, were to visit the wax museum . . . he placed himself in a cupboard behind a pedestal in such a way that his head alone remained visible. As we walked through the gallery, we passed in front of him, but his eyes looked so glazed and his features were so still, that not one of us recognized him. . . . Impatient for our attention, he began to move and speak and frightened us out of our wits."

Elisabeth's original plan had been to stay in Vienna until she could return to France. But the ongoing events of the French Revolution did not inspire confidence that she might go home anytime soon. She was still an antirevolutionary who, like many other French people, was appalled by the extreme violence of the Reign of Terror. Her name remained on the list of émigrés, and back in Paris, Pierre was fighting for her reputation and their joint property. When the revolutionary authorities questioned him about his wife's hasty retreat from France, he defended her decision on the grounds that she was furthering her knowledge of the arts. Though this might have been incidentally true, Pierre was attempting to use a loophole for those in the arts who left France to continue their education. In 1793 Pierre published a defense of his wife's actions titled *Historical Account of the Life of Citizen Le Brun, Painter.* His efforts to defend Elisabeth's character and remove her name from the list of émigrés were fruitless. A year later, as a last resort, he sued for divorce, which was now legal under the new regime. Divorce was the easiest way to protect himself and his property; however, he continued to lobby for his ex-wife and support her and their daughter's eventual return to Paris.

Although Elisabeth could have chosen to remain in Austria, she became intrigued by descriptions of the powerful female ruler of Russia, Catherine the Great. A social acquaintance, Prince Charles Joseph de Ligne, encouraged Elisabeth to go to Saint Petersburg, where he assured her the empress Catherine would greet her with pleasure. "Everything the Prince de Ligne had told me about Catherine inspired me with a desire to see this sovereign." And a short stay in Russia, Elisabeth figured, could make her a fortune to bring back to Paris. She had reason to think so, for in Vienna she had painted several wealthy Russian nobles including Count Grigory Chernyshev (though her acquaintance with this particular man was one she would later regret). She spoke no Russian, but she wasn't worried. She knew that most Russian aristocrats spoke French, the language of international sophistication.

Never one to shy away from a daring new opportunity, Elisabeth departed Vienna with her entourage on April 19, 1795. With some short side trips along the way, the journey took ninety-seven days, over numerous primitive and sandy roads.

Baron Grigory Stroganov, 1793

Baron Grigory Stroganov's career, like that of so many other men of his station, began in the military and eventually led to the diplomatic corps. Elisabeth painted two portraits of him, but only this work survives. Here he is twenty-three years old. Despite his formal attire, with satin waistcoat and fur-lined red velvet jacket, Grigory seems familiar and comfortable with the artist and she with him. His eyes twinkle as he plays the role of the aristocrat and appears ready to flash a warm smile.

The Reign of Terror

Established in 1792, the French National Convention was made up of representatives democratically elected by (male) voters. Among its first actions were getting rid of King Louis XVI and declaring France a republic. Things soon got out of control, with many disagreements arising over the direction the Revolution should take next. France was also at war with other countries, adding a layer of paranoia about enemies plotting against the new government from the inside. During the Reign of Terror, tens of thousands of people were arrested on suspicion of antirevolutionary sentiment; many were publicly executed. This horrifying chapter in history eventually ended with the overthrow of Maximilien Robespierre, leader of the National Convention's Committee of Public Safety, the group responsible for arresting and executing anyone they thought was an enemy of the Revolution.

Count Grigory Chernyshev with a Mask in His Hand, 1793

Count Grigory Chernyshev loved to give parties where he would serve his guests, a surprising gesture for a man of his stature. He wrote poetry and plays and loved theater, to which Elisabeth alludes with his mask and loose black cloak (called a domino). Elisabeth framed his impish youthful face with a halo of hair, each strand meticulously defined with a stroke of her brush.

Being Great

Imagine being such a celebrated painter that the day after you arrive in Saint Petersburg, you receive an invitation to meet Catherine the Great in person. This is what happened to Elisabeth, according to her memoir. She barely had time to recover from her journey when a member of the Russian court called on her to make arrangements for an audience. At one o'clock the following afternoon, Elisabeth found herself in Empress Catherine's summer palace at Tsarskoe Selo, a long building with pavilions at both ends that rivaled—if not surpassed—the magnificence of Versailles. The interior was painted blue with white trim; gilded statues, cornices, and decorations over the windows adorned the space. Unfortunately for the weary artist, she had no choice but to wear a simple dress that she had brought with her instead of a more appropriate formal gown, which worsened her anxiety about meeting the powerful Russian sovereign.

"I arrived at the Empress's quarters trembling, and a few moments later I was face to face with the ruler of all Russia." Overcome by awe and surprise—for Catherine was much shorter and plumper than Elisabeth expected—she forgot to kiss the empress's hand, a breach of protocol she later recalled with embarrassment. Still, even this blunder did not deter Catherine from making Elisabeth feel comfortable: "She addressed me immediately in a voice full of sweetness, if a little throaty: 'I am delighted to welcome you here, Madame, your reputation precedes you. I am very fond of the arts, especially painting. I am no connoisseur but an amateur.'" In truth, Empress Catherine was a voracious consumer of literature and the arts and was a generally enlightened leader. She purchased entire libraries and had insiders to tip her off in advance about the upcoming sale of important art collections. She carried the torch from Peter the Great to westernize Russia with military and political might, innovative cultural ideas, and socially progressive policies. The invitation Catherine extended to Elisabeth stemmed not only from her admiration of the brilliant artist but also from her desire to connect Russia with the cultural life of Europe.

During her time in Russia, Elisabeth would reach the pinnacle of her artistic career, amass a personal fortune, and socialize at the highest level of Russian society. Yet her eventual departure from the country followed the greatest heartbreak of her life. It would be an eventful six years, beginning when Elisabeth was forty years old and Julie just fifteen. They were still accompanied by Julie's governess and by Auguste de Rivière—all four of them now 2,700 miles from home.

Elisabeth was entranced by her new environment: "Even more magnificent than the Saint Petersburg I pictured in my imagination was the place itself. I was enraptured by the sight of its monuments, its beautiful mansions and wide streets, one of which, named the Perspective, is almost three miles long. The beautiful Neva [River], so bright and limpid, traverses the city, crowded

Palace of Her Imperial Majesty in Tsarskoe Selo, engraving after a 1761 drawing by M. I. Makhaev

with ships and small boats constantly moving to and fro, enlivening this lovely city in a charming manner."

As with her entries into Naples and Vienna, Elisabeth already had connections in Saint Petersburg. The Stroganov family in particular would play an important role in her life as friends, patrons, and guides to help their French friend navigate Russian culture and the imperial court.

In autumn 1795, Count Alexander Stroganov delivered a commission from Empress Catherine: Elisabeth was to paint the monarch's granddaughters, Alexandra and Elena Pavlovna, daughters of Catherine's only child, Paul. For the double portrait, Catherine paid the royal sum of 3,000 rubles, for which Elisabeth must have been grateful, given a series of unfortunate events that had gravely set back her finances. During her first few months in Saint Petersburg, Elisabeth had wasted no time securing portrait commissions and earning 15,000 rubles. She entrusted this money to a banker who promptly went bankrupt and lost it all. Then, one night, she returned home to hear from Mrs. Charot that a servant had stolen all the money Elisabeth had saved at home in gold coins. He was found and arrested, but while some of the gold was returned to her, it was not nearly what she had earned.

Portrait of Catherine II, Empress of Russia by Vladimir Borovikovsky, 1794

Although this likeness may not seem to convey the same authority as a coronation portrait, it is still a depiction of military might and royal power. Here Catherine takes a walk with her greyhound in Tsarskoe Selo near Saint Petersburg. She subtly points to the Chesme Column visible in the background, which she commissioned to commemorate three Russian victories over the Ottoman Empire. Catherine's remarkable blue silk robe, which looks more Eastern than European in style, shimmers with a wealth of pearls, especially at the cuffs. She loved to collect gems and precious objects, including pearls in irregular and unusual shapes.

Empress of All the Russias

In 1773 the French Enlightenment philosopher Denis Diderot visited Empress Catherine. They spent a lot of time together, she thirsty for knowledge and he eager to know the woman he thought might become a model of enlightened leadership. Diderot gave her the moniker "the Great," by which we know her today.

Catherine the Great was born in 1729 as Princess Sophie Friederike Auguste von Anhalt-Zerbst-Dornburg of the Kingdom of Prussia. She arrived in Saint Petersburg at age fifteen as a prospective bride for her second cousin Peter, heir to the Russian throne and grandson of Peter the Great. Sophie changed her name to Catherine, the name of Peter the Great's wife. The new Catherine and Peter were married in 1745, but they were not a good match. Catherine educated herself in everything from military history to philosophy and the arts. She absorbed all she could about Russia, including its language, customs, and religion. Peter had little in common with his bride, and the unhappy couple became estranged. After Peter became emperor, he isolated and humiliated Catherine, determined to end their marriage.

Catherine felt that Peter created discord at court and was embarking on a disastrous path for the future of Russia. Six months into his reign, in July 1762, Catherine staged a coup—an overthrow of her husband's rule. Aided by Grigory Orlov and his powerful family, she occupied the Winter Palace while Peter was away and claimed the official title of Empress Catherine II for herself. When Peter returned from vacation, he realized his fate. Two of the Orlov brothers arrested Peter and forced him to abdicate the throne. Eight days later he died under mysterious circumstances.

For thirty-four years Catherine ruled Russia, expanding it into a military and cultural stronghold and becoming the world's most powerful woman in the process. She reorganized provincial governments to give them more power on a local level, created a new legal code in line with Enlightenment ideals, and founded the Smolny Institute, the first public educational institution in Europe for girls. As enlightened as she was, however, she expanded the system of Russian serfdom because she relied on support from the nobility, who profited from this form of indentured servitude. A half million serfs worked on land that Catherine or her extended family owned. She also forced Jewish people to live in specific areas of the empire (called the Pale of Settlement), curtailing the operation of their businesses and limiting social integration.

It is hard to overstate Catherine's acumen and voraciousness as an art collector. Over the span of her monarchy, she acquired around four thousand paintings, ten thousand drawings, thirty-eight thousand books, and ten thousand gemstones. The State Hermitage Museum, still one of the most important art collections in the world, includes many of these works of art.

Elisabeth's painting for Empress Catherine shows the two duchesses gazing sweetly at the viewer while presenting a miniature portrait of their grandmother. In her first version of this painting, Elisabeth portrayed the girls in Greek tunics—a choice for which she would claim she was chastised by Platon Zubov, the last in a series of men presumed to be Catherine's lovers and a powerful member of the court. He supposedly said that Catherine was displeased with the painting and insisted that Elisabeth change the dresses to cover the girls' bare arms.

Despite this unfortunate start in Saint Petersburg, Elisabeth ultimately pronounced the Russians generous and hospitable, going so far as to say that she found Russian women warmer and more approachable than French women. Among her closest friends was Princess Catherine Dolgorukova, who had many passionate suitors before she married Prince Vasily Dolgorukov. The couple had five children, three of whom lived to adulthood. A lady-in-waiting to Catherine the Great, she was renowned for her intelligence and, like many women of her station, she was well traveled, having spent time in Dresden, Vienna, and Paris. The princess welcomed the artist and her daughter warmly into her world, bringing them to theatrical performances and immersing them in high society. She even invited them to stay at her country estate in Alexandrowski for a week. There Elisabeth experienced a taste of the Paris she had left behind—dining well, singing, and directing *tableaux vivants* (living pictures), an entertainment that involved guests donning costumes and holding props to enact live compositions, as though the artist were creating paintings in real life instead of on canvas. In May 1796 Princess Catherine requested a portrait from Elisabeth in the style of her famous *Sibyl*. The result was a tour de force for its depiction of the princess as a woman who chose to be recognized for her intellect and talent. Once the painting was finished, the princess sent Elisabeth a beautiful carriage and placed a bracelet on her arm made of a plait of hair set with diamonds reading: *Adorn she who adorns her century*.

Catherine the Great died just sixteen months after Elisabeth's arrival in Saint Petersburg. Only four days before her death, the legendary ruler had a portrait sitting with the famous French artist. Elisabeth would keep the pastel portrait she had made of Empress Catherine for the rest of her life. (Though it is now missing, it was listed in the inventory of Elisabeth's estate when she died.)

Catherine's son, Paul I, ascended the throne amid unrest and protest. Paul had a distant relationship with his mother, who made it known that she wanted her grandson, Alexander, to be her successor because she doubted Paul's capacity to serve. Elisabeth vividly recalled Paul as a moody and unpredictable ruler. Shortly after Catherine's death, Paul joined Britain and Austria in a war against France—and then reversed his decision. Locally, he issued

The Daughters of Paul I, Grand Duchesses Alexandra Pavlovna and Elena Pavlovna, 1796

Elisabeth conveys the young duchesses' fair skin ("so fine and delicate that one imagines they lived on ambrosia") and light curls swept back from their faces by tiaras decorated with roses. Elena lovingly displays a medallion worn by Alexandra, which contains a miniature portrait of their grandmother, Catherine the Great.

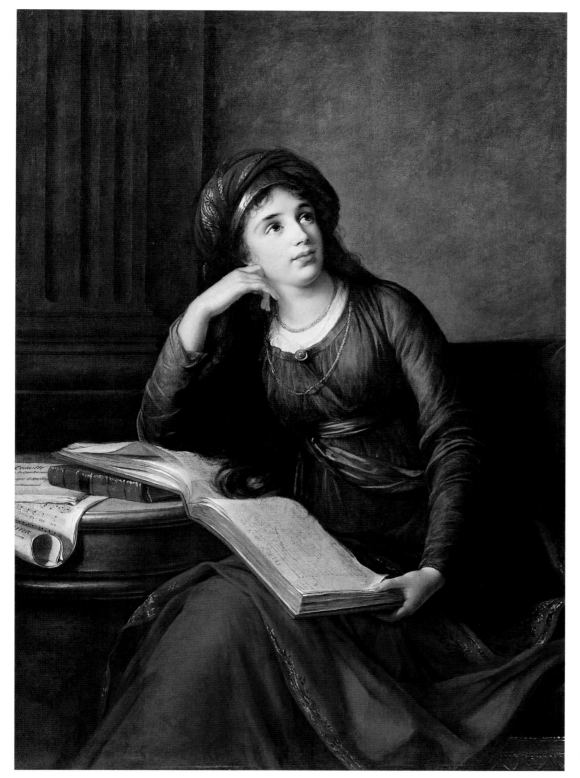

Princess Catherine Dolgorukova, about 1797

This portrait of Elisabeth's friend Catherine situates the sitter between the real and the ideal. As she had done with Emma Hart (p. 63), Elisabeth dressed Catherine as the Cumaean Sibyl. Unlike Emma's portrait, this work presents Catherine as a real woman with her own intellectual interests. She is reading a work of fiction set in classical Greece and a treatise by the Enlightenment philosopher John Locke titled *Some Thoughts Concerning Education*. Also shown is the score for a comic opera and a libretto by the German composer Jean-Paul-Égide Martini, whose most famous work, "Plaisir d'amour" (Pleasures of Love), became enormously popular in salons throughout Europe (and in the twentieth century, it was recorded by many singers including Marianne Faithfull and Joan Baez, and it inspired the song "Can't Help Falling in Love" sung by Elvis Presley).

ever-changing lists of new laws, and according to Elisabeth, the smallest infraction might result in exile to Siberia. People's lives under Paul changed dramatically in Saint Petersburg, and not for the better.

The Rift

At this dark time in Russian history, Elisabeth's own life also took a turn for the worse. Her beloved daughter was now a talented and graceful young woman of seventeen. Fluent in several languages, she would sing arias while accompanying herself on the piano or playing the guitar. Especially gratifying to Elisabeth was Julie's aptitude for painting. Elisabeth never attended a social gathering without Julie; mother and daughter beguiled all of Saint Petersburg society. Their relationship seemed remarkably warm and close (although we only have Elisabeth's side of the story). According to friends of the artist, Julie's bidding was her adoring mother's command.

But a shadow soon fell between them. It was that of Countess Elisabeth Chernysheva, wife to Count Grigory Chernyshev, whom Elisabeth had met in Vienna—likely at an event hosted by their mutual friends the Stroganovs—and whose portrait she had painted in 1793. In Saint Petersburg, when the artist was at work in her studio or otherwise occupied, she allowed Julie to spend time with the young countess, who was only seven years older than Julie. There were sleigh rides in winter and evenings spent in the intimacy of the Chernyshev household. Before long, Julie met and, with the countess's encouragement, fell in love with Count Chernyshev's private secretary, Gaëtan Bernard Nigris. Gaëtan was fourteen years older than Julie, from a modest background, with an unhealthy pallor and a melancholy air. Opposed to a man "without talent, without a fortune, without a name," and having heard some negative things about him, Elisabeth was dismayed at her vivacious daughter's decision to rush into marriage. Elisabeth worried—correctly, as it turned out—that the union would make Julie unhappy. But Julie was excited by the romance of it all, and her mother's objections fell on deaf ears.

Supporting the match were the Chernyshevs and their powerful allies, who pressured Elisabeth for a generous dowry for Gaëtan and even threatened to enlist the backing of the erratic emperor Paul. If this had happened, Elisabeth wrote, she would have declared that "a mother has rights older and truer than that of all of the world's emperors." She may have claimed not to be scared by the Russian court, but she was admittedly terrified of ruining her relationship with her daughter, who had been the center of her universe. It caused Elisabeth great pain to see Julie losing trust in her and becoming distant. Ultimately, the embattled mother agreed to what she considered a disastrous marriage, and she wrote to Julie's father, Pierre Le Brun, asking him to send his consent from Paris. To pay for Julie's dowry, Elisabeth used

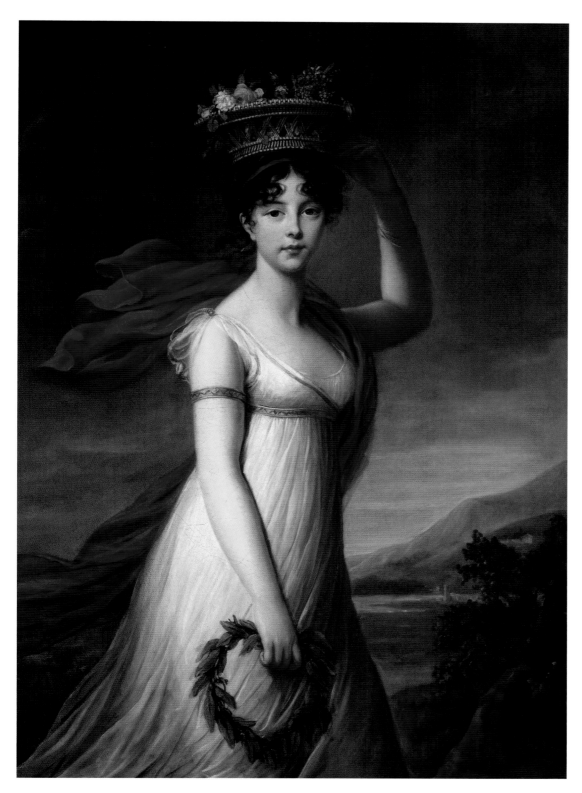

Julie as Flora, Roman Goddess of Flowers, 1799

Elisabeth's admiration for her daughter is apparent in this portrait of Julie as the Roman goddess of flowers. Julie balances a basket of carefully painted blossoms and grapes; in her right hand she grasps a heart-shaped wreath of laurel leaves. The Italian coastline and a juniper bush embellish the classical theme.

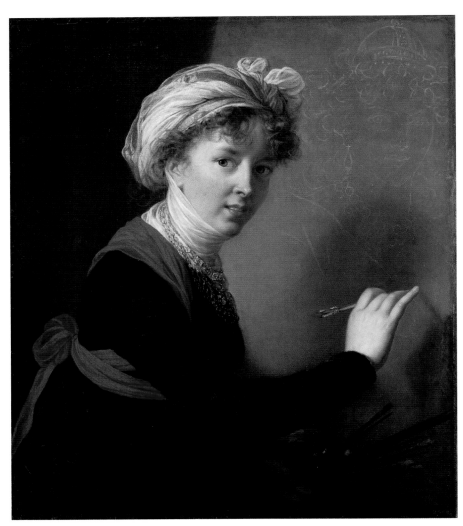

In her self-portrait for the Imperial Academy of Fine Arts, Elisabeth draws a sketch of Empress Maria wearing a small crown scattered with diamonds. The artist shows herself sporting a multistrand gold-link necklace interspersed with diamonds. A large pendant diamond hangs at her bodice, set off by her dark dress. Elisabeth found it challenging to paint diamonds; however, in this work, the jewels were critical to the meaning of the painting. Showy and magnificent, these diamonds signified the artist's success and were also a nod to Catherine the Great and her love of the most precious stone.

the proceeds of numerous paintings she had made in Saint Petersburg, and she gave her daughter gifts of exquisite jewelry, including a diamond bracelet. But none of it regained her Julie's affection. Julie married Gaëtan on August 31, 1799. The mother and daughter who had been inseparable, traveling the world together for nearly a decade, were never the same. Elisabeth was heartbroken. It only made things worse that, soon after the wedding, Julie's infatuation with Gaëtan already seemed to be wearing off. The couple would separate a few years later.

Low to High

The following spring brought a fresh wave of grief. A letter arrived from Etienne with the news that their mother had died in Neuilly, France, on April 9, 1800. This time in her life, Elisabeth wrote, "was devoted to tears."

Yet only two months later, the hardworking artist, who had never stopped improving her skills, reached the pinnacle of success. On June 16 she received the highest award of her career: election as an honorary free associate of Russia's Imperial Academy of Fine Arts. She was the first woman painter ever to receive this distinction. Of all the events that took place during her travels, she counted her induction into the Imperial Academy among her most cherished memories: "Upon learning from Count Stroganov, the Minister of Fine Arts, of the honor, I arranged to have the uniform of the academy made for me: a lady's riding habit consisting of a little violet vest, a yellow skirt, a hat with black feathers. At one o'clock I entered a salon opening into a large gallery at one end of which Count Stroganov sat at a table. I was invited to approach him. To do this I had to walk the length of the gallery, on either side of which were tiers filled with spectators. Since I recognized many friends and acquaintances in this crowd, I reached the count without losing my composure. He made a brief, very flattering speech, then presented me, on behalf of the emperor, the diploma appointing me a member of the academy. Everyone applauded so vigorously that I was moved to tears. Never shall I forget this sweet moment."

Upon her admission to the Academy, Elisabeth began working on a self-portrait, by her reckoning the finest she would ever produce. "I began my self-portrait for the Academy of Saint Petersburg at once, and I drew myself painting, palette in hand," she recalled.

Unlike in previous self-portraits, Elisabeth wears an elaborate piece of diamond jewelry in a flattering imitation of the empress Catherine's glittering display of power. This self-portrait served as a farewell of sorts to Saint Petersburg, as it is the last extant work by Elisabeth from her time spent in that city.

Meanwhile, back in Paris, Pierre was circulating a petition to have her name removed from the list of émigrés, and it was signed by more than

Prize Medal in Honor of Elisabeth Vigée Le Brun, 1829

A bronze medal coated in gold would be produced by the Imperial Academy of Fine Arts in Elisabeth's honor. One side of the coin reads, "In remembrance of the great Le Brun," while the other side shows a paint palette from which the sun's rays emanate, a metaphor for Elisabeth's radiant talent as a painter.

The Dazzle of Diamonds

Catherine the Great loved diamonds. Rare and hard to cut, diamonds were only for the extremely wealthy. Grigory Orlov gave Catherine a famed 190-carat Indian diamond, which in 1774 became part of the Russian imperial scepter. The jewelry Catherine wore signaled the prosperity, wealth, and geographic reach of her power—from Siberia to the Urals, which supplied enormous mineral wealth. Upon visiting the imperial bedchamber, the German botanist and geographer Johann Gottlieb Georgi recorded: "Her room is like a priceless jewel case. The regalia is laid out on a table under a great crystal globe through which everything can be examined in detail. . . . The walls of the room are lined with glass cabinets containing numerous pieces of jewelry set with diamonds and other precious stones as well as insignias and portraits of Her Imperial Majesty, snuff boxes, watches and chains, drawing instruments, signet rings, bracelets, sword belts and other priceless treasures among which the Empress chooses presents for giving away." Elisabeth, too, throughout her descriptions of living in Russia, frequently mentioned the sheer multitude of diamonds—set into jewelry, clasps, and hair ornaments; woven into buttonholes and fabric; and loose, stored under glass globes presumably for future use.

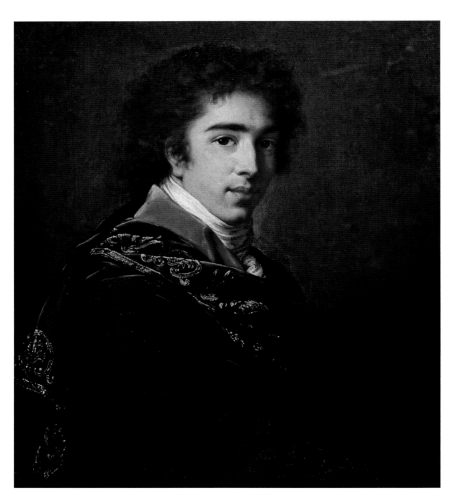

Prince Ivan Baryatinsky, 1800

By age twenty-eight, Prince Ivan Baryatinsky was already a cultured nobleman and diplomat. Draped in an indigo blue velvet mantle, exquisitely embroidered in gold with a leaf pattern, he held his body at an angle while gazing directly at the artist, as if turning to answer a question. Ivan began his military career when he was ten years old. He later served as secretary of the Russian embassy in London and as an ambassador in Munich, then part of Bavaria. When his father died in 1811, Ivan became one of the wealthiest men in Russia. Elisabeth dreamily recalled seeing Ivan at an earlier imperial ball given by Catherine the Great, where a thousand candles lit the many beautiful women drifting about. Ivan memorably whisked Elisabeth onto the ballroom floor to dance a Polonaise, in which couples hold hands as they promenade with graceful steps and turns.

250 artists and intellectuals. In June 1800 Elisabeth's French citizenship was restored, paving the way for her safe return home. The artist was certainly ready to leave Saint Petersburg, craving distance from a place where she had suffered greatly. She was leaving on a high note, as the first woman elected to the Imperial Academy, but also on a very low one: traveling for the first time in eleven years without Julie as her companion. On October 15, 1800, she left Saint Petersburg to spend a few months in Moscow being wined and dined by the aristocracy but often declining their entreaties to paint their portraits. She spent most of her time in quiet contemplation, healing her emotional wounds, coming to terms with a deep anger she nursed toward those who had wronged her, and worrying about the fate of her only child. She made exceptions for Prince Ivan Baryatinsky and for Countess Stroganova, by then separated from Count Stroganov. As a gesture of thanks to the countess for the loan of her Moscow home, Elisabeth painted a splendid portrait of the countess's fifteen-year-old daughter, whose father was Ivan Rimsky-Korsakov, a former favorite of Catherine the Great.

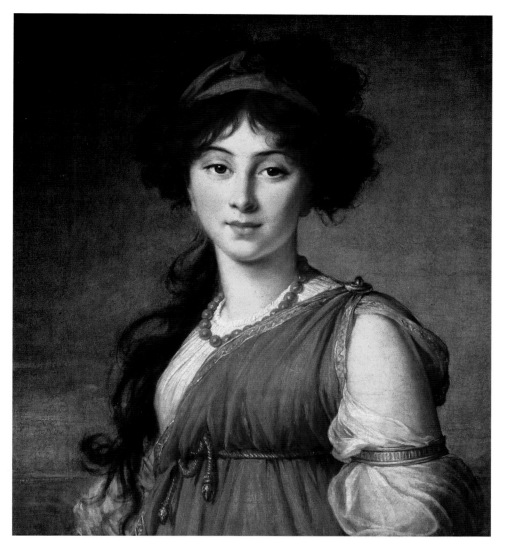

Varvara Ivanovna Ladomirskaya, 1800

Varvara Ivanovna was one of four children born out of wedlock to Countess Stroganova and Ivan Rimsky-Korsakov. Some people criticized the rise in "illegitimate" births in the 1700s as the result of Russia's westernization. But creative arrangements could be made by the upper classes to avoid stigma. Countess Stroganova's children were granted noble status by imperial decree in 1798. In this portrait, fifteen-year-old Varvara fixes her almond-shaped eyes on the viewer, her lips offering the hint of a smile. Her Grecian-inspired tunic is trimmed in gold and held at the shoulder by a gold pin, and she wears a necklace of coral or amber beads to match her garment.

Finally, after a dozen years living in exile, Elisabeth prepared to return to France, having made her fame and fortune. On the road in March 1801, she learned of the assassination of Paul I, which allowed his twenty-three-year-old son, Alexander I, to succeed to the Russian throne. Elisabeth seems to have debated making one more portrait of the new emperor and empress but then heeded her doctor's advice to leave Russia and stop on the way to take in the famous therapeutic waters in Karlsbad, Bohemia, to provide relief for her physical stress and mental turmoil. She had much to be proud of. She had produced more than fifty remarkable paintings and, if not for her personal troubles, could easily have spent the rest of her life increasing her fortune and painting the Russian nobility, who clamored for more of her work. She left with Auguste de Rivière but without Julie, reflecting on all that had been gained and lost during these years in Russia.

5

The Long Way Home

Elisabeth painted the queen wearing a single strand of pearls and a gold diadem that holds a miniature portrait of her husband, Friedrich Wilhelm III. As a young girl, Luise enjoyed a wide curriculum of study, including French, poetry, ancient literature, and music. Upon her marriage to Friedrich, with whom she had ten children, seven surviving to adulthood, she was warmly embraced by Prussian society. But she was much more than an attractive consort. The queen's political acumen made her a good companion to the king, who was known to seek her advice on many matters of state and warfare, including Prussia's troubled peace and eventual war with France under Napoleon. When Luise died at the tragically young age of thirty-four, Napoleon allegedy remarked that the king had lost his best minister.

"On drawing near France again, I picture so vividly the horrors that took place there that the prospect of revisiting the scene of these atrocities frightens me," Elisabeth wrote. "It feels as if I were treading on a tomb, and I am not the mistress of my dark thoughts." After an absence of twelve years, and without Julie at her side, Elisabeth faced her homecoming with as much dread as joy. The Reign of Terror and the deaths of her queen, her mother, her dear friend Rosalie, and so many others weighed on her mind. Nothing would be the same; perhaps Paris would never feel like home again.

She had plenty of time to dwell on her fears during her months-long journey. The route from Russia was as difficult as any she had described in her memoir: she slept most nights in her carriage, and stops along the way

Napoleon the Unstoppable

Napoleon Bonaparte, born in 1769, seized control of the French government in a coup d'état (a military show of force) in 1799. He was well positioned for this takeover thanks to an illustrious military career in which he rose to the rank of general before his twenty-sixth birthday. By 1796 Napoleon commanded a large portion of the French army. His successes during the revolutionary wars made him a national hero; he drew the attention of powerful revolutionary figures and became involved in French politics. After several years defending French military interests in Egypt, he returned to Paris and assumed power, putting an end to the chaotic years of the French Revolution.

The Revolution was idealistic, unpredictable, and violent. Three different governments ruled over the course of ten years, while the French people faced an unstable economy, a series of uprisings at home, and multiple wars against an allied Europe. It was the perfect environment for a young and capable military officer to capture the hearts of the people with the promise of security and stability.

In the beginning, Napoleon kept up the mirage of republican rule by having himself appointed to public office—though in truth he held all the power. He instituted several reforms, including a new legal code, a centralized government, and a public education system open to all students. These changes were based on the themes of *liberté, égalité, fraternité* (liberty, equality, brotherhood)—one of several rallying mottoes that originated during the Revolution. But as time went on, Napoleon grew increasingly authoritarian. He abolished the free press and reintroduced the institution of slavery in the French Caribbean colonies to bolster the economy. Eventually, Napoleon turned away from the core principles of the Revolution, ending elections outright and bringing back a hereditary monarchy to rule France.

In 1804 Napoleon crowned himself emperor of France. He returned to his military roots and conquered Austria, Prussia, and Spain as part of a campaign to expand his power. However, he eventually faced defeat at the hands of the Russian army in 1812. He was exiled to Elba—an island off the Italian coast but part of the French Empire—in 1814. Napoleon briefly returned to France in 1815 to reign once again for the "Hundred Days," a period of about three months during which he attempted to regain control of the government. Later that year, Napoleon faced his ultimate defeat at the infamous Battle of Waterloo. The last several years of his life were spent again in exile—this time more closely watched—in the British territory of Saint Helena, a remote island in the South Atlantic, where he died in 1821.

Bonaparte as First Consul by
Antoine Jean Gros, 1802

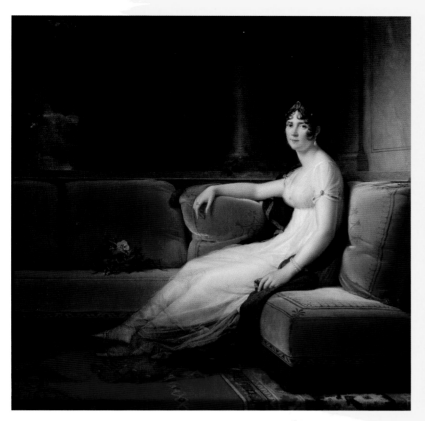

Portrait of the Empress Joséphine
by François Gérard, 1801

Josephine the Fashionable

The first wife of Napoleon and the first empress of France, Josephine was elegant, graceful, and a fashion trendsetter. The dress she wears in this painting reflects a number of different influences. Josephine grew up on the French colonial island of Martinique, in the Caribbean, where she would have seen the traditional white cotton gole (dress) that women of color wore and which influenced her approach to a signature style. The high-waisted gown also reflects the clothing worn by the ancient Greeks and Romans, which would have been visible in wall paintings newly discovered by archaeologists. The use of fine muslin from India and the gown's simple, flowing lines contrast dramatically with the bone stays, petticoats, and yards of embroidered silk that had defined Queen Marie Antoinette's formal wardrobe. The empress's elongated figure, emphasized by the dress's unstructured silhouette, gives the impression of her body melting into the cushions. Josephine casually drapes her right arm over another cushion, her skin's marble whiteness in stark contrast to the soft, brown velour. A diadem that looks simultaneously regal and modest holds back her curls, again in stark contrast to the bows, ribbons, and jewels that adorned the opulent hairstyles worn by Marie Antoinette and the ladies of her court.

offered watery soup and perhaps a thin piece of chicken. When she reached Potsdam, where she would rest at the invitation of the Queen of Prussia, Luise von Mecklenburg-Strelitz, Elisabeth savored the unfamiliar taste of good coffee. During her three-month stay, she painted a half-length portrait of the queen that reflected the artist's first impression of her as an extraordinarily beautiful woman. She portrayed her almost as a fairy tale character: full red lips, ivory skin, and ethereal clothing gently fluttering in the breeze.

At this point, midway between Saint Petersburg and France, Elisabeth began to encounter emissaries from the French Republic under Napoleon Bonaparte, who had seized power in 1799. She visited with the Marquess of Chateaugiron, whose tricolor cockade (a knot of ribbons typically worn on a hat) proclaimed his allegiance to the new ruler; the sight of it upset the artist and made clear that an unfamiliar world awaited her.

When she finally arrived in Paris, in January of 1802, she was warmly greeted by Pierre, Etienne, Etienne's wife, Suzanne, and their young daughter, Caroline. At first Elisabeth was somewhat soothed by the tremendous effort Pierre had made to prepare their home, the Hôtel Le Brun on the rue du Gros

Chênet (although she couldn't help noting that all his redecorating had been paid for with her money). The couple had remained in contact as Julie's parents, and they stayed connected professionally and financially. Their 1794 divorce had less to do with their long separation than with the property Pierre sought to protect from seizure by the revolutionary government. They seemed to retain a level of affection for each other, and Elisabeth admired Pierre's meticulous taste, including curtains edged in golden silk embroidery and a crown of gold stars placed above her bed. She resolved to settle into life in Paris, but it wasn't easy.

For one thing, she discovered that, during the Revolution, Etienne had flipped political sides and sworn allegiance to the National Assembly. Between 1795 and 1799, he served as a high-ranking member of the committee responsible for seizing the property of citizens who had fled the country . . . like his sister. When, on her return, Elisabeth learned of her brother's activities, it drove a wedge between them. Etienne, a modestly successful poet and playwright, went so far as to publish the poem "Verses by a Brother on the Enmity That Has Arisen between Him and His Sister," though Elisabeth never mentioned their rift in her memoir.

Elisabeth, now forty-six and an international celebrity, carried on doing what she always did when starting over in a new place: she strategically deployed her talent, charm, and fame to attract new clients and forge

Next Generation: Gérard

Baron François Pascal Simon Gérard, born in 1770, worked in the studio of Jacques Louis David, where he aspired to become a history painter. His dramatic painting *Belisarius*, depicting a Byzantine general who was blinded by a jealous Roman emperor, drew critical praise and launched François's solo career. His 1801 painting of Empress Josephine made him the darling of the aristocracy at a time of increased demand for society portraits. Soon he had more offers for commissions than he could possibly accept. Elisabeth perhaps saw herself in this rising star, who was fifteen years younger. She wrote, "I was dying to meet this great artist, known as much for his intelligence as his remarkable talent. I found him entirely worthy of his reputation, and I have always counted him among my circle."

Belisarius by François Gérard, 1797

new friendships. Adjusting to political reality, she graciously accepted a visit from Napoleon's brothers, who wished to meet the renowned artist and view the paintings she had brought back with her from Saint Petersburg. Lucien Bonaparte, who shared a love of classical history with his older brother, had high praise for Elisabeth's *Sibyl*.

She attended a musical evening at the home of Mrs. Ségur, who "had gathered about her the most influential people of the day." She dropped in on such prominent artists as Jean Baptiste Greuze and Joseph Marie Vien, who was the last to possess the title of First Painter to the King. During her visit to the studio of François Gérard, Elisabeth admired his portrait of the empress Josephine, who appears as a vision of classical austerity, as if carved out of a slab of marble.

Perhaps as a way to connect with her past, and "because I still could not shake off my melancholy," Elisabeth decided to hold parties in the evenings. "On one occasion I brought together all the principal artists of the period . . . later I held a ball where Mrs. Hamelin, Miss Trenis, and several other well-known dancers performed. . . . I remember that Miss Dimidoff danced the Russian waltz so well that people stood on the tables to watch her."

She set up a little theater in her house for staging comedies, in which her old friend Auguste de Rivière played a part, and visitors from Russia and Germany dotted the audience. On her own, she frequented old haunts like the Louvre, where she lingered so long one evening that she was locked inside the museum. "I found myself imprisoned among all these beautiful statues, which I was now in no state to admire; they looked like ghosts. . . . Finally, after searching for the thousandth time, I noticed a small door and banged on it so hard that someone heard and opened it for me."

The usually busy artist was less productive at this time in her career. She submitted only two paintings, including her *Sibyl*, to the Paris Salon of 1802. Try as she might, Elisabeth couldn't find peace. "Despite all the distractions offered me by Paris, great black clouds of sadness hung over me still and threatened to smother me in the midst of my enjoyment. . . . I thought a journey might finally put an end to this painful state of mind."

On April 15, 1803, Elisabeth set out for London. The signing of the Treaty of Amiens had suspended hostilities between Britain and the French Republic, giving the artist her first chance to explore England. By the time

Building the Grandest Museum in the World

Once a royal palace and then the home of the Royal Academy of Painting and Sculpture, the Louvre became the national museum of the new republic in 1793. It was open to the public three days a week to exhibit the wealth of art that the government had confiscated from émigrés and churches. Pierre Le Brun had been intimately involved in cataloguing these collections as a specialist for the museum, serving in the roles now titled "curator" and "registrar." He is credited with advising that paintings should be arranged by schools. In 1802, the same year Elisabeth returned to Paris, Napoleon appointed Vivant Denon as the museum's first director, and Pierre was subsequently dismissed from his position. When Elisabeth was accidentally locked inside the Louvre, she must have been mesmerized by the magnitude of the art collections that graced its walls.

Circular Gold Brooch by an unknown artist, about 1800

Imagine wearing a small painting of your partner's eye as a piece of jewelry, maybe a pin or a ring. These items were considered tiny portraits and extremely personal, and lovers would give them to each other as secret tokens of affection. Why the eyes and not, say, the mouth? The eyes in these miniature works captured the lover's gaze. These pieces of jewelry were often encased in elaborate settings with gold, pearls, and gemstones.

the treaty was broken, about a month after her arrival, Elisabeth had already befriended the Prince of Wales, who arranged for her to continue traveling freely about the country. She painted a portrait of the forty-year-old heir to the British throne, and she later provided readers of her memoir with commentary about his romantic adventures: "As he had been one of the most handsome men in the three kingdoms, he still saw himself as the darling of the ladies," she wrote. The Prince of Wales thought so well of Elisabeth's portrait that he gave it to his true love, Maria Fitzherbert. She was a twice-widowed commoner and a Roman Catholic whom the prince had married in 1785 in a secret ceremony considered invalid by English law. Maria chose to leave for France, aware that their union would never be accepted in Britain. Had they sought the approval of the sitting king George III, the prince might have lost his place in the line of succession to the throne. By the time Elisabeth painted his portrait, the prince had married—and separated from—his first cousin, Duchess Caroline of Brunswick, with whom he had a daughter, and he'd had numerous other liaisons. But he never forgot Maria. In addition to this portrait, he sent her a miniature painting of one of his eyes, and she sent one of hers in return. On his deathbed, the king asked to be buried with the eye miniature of Maria. These portraits of eyes, in watercolor on ivory and often surrounded by gemstones, were all the rage among those who could afford them.

During her two years in England, Elisabeth toured Westminster Abbey and Saint Paul's Cathedral, and she enjoyed seeing the Isle of Wight and the city of Bath. She visited castles and their owners, expanding her circle of friends and new clientele from the English court, and she met prominent people such as the renowned poet Lord Byron.

A Daughter's Return

While Elisabeth was abroad, Julie and her husband, Gaëtan, came to Paris on an assignment to purchase works of art for a Russian nobleman. Although her relationship with Julie was still strained, Elisabeth was eager to see her daughter again. In the summer of 1805, the artist crossed the English Channel to Rotterdam, where she expressed irritation at being delayed for over a week. She failed to mention in her memoir that she was traveling during wartime, just as the French were gathering their forces to fight the British Royal Navy over control of the channel.

On reaching Paris, Elisabeth returned to the Hôtel Le Brun. One can only imagine the tumult of emotions mother and daughter felt upon seeing each other again. Julie's choice of husband had divided them—until Gaëtan, true to Elisabeth's assessment of him as unworthy of her daughter, left a heart-broken Julie behind and went back to Russia alone. The marriage ended in divorce. Wrote Elisabeth, "When all was said and done, she was my daughter. Although I was vexed that I could not persuade her to come live with me, I still saw her every day, and this was a source of immeasurable joy."

Immersed once again in her career and her Paris life, Elisabeth received a surprising commission from Napoleon: a full-length portrait of his sister Caroline Murat posing with her daughter Laetitia. "It is likely that Bonaparte's rancor toward me did not go deep. . . . He sent Mr. Denon to order a portrait of his sister, Mrs. Murat. I didn't feel it was wise to refuse, even though I was offered only 1,800 francs, or half my usual fee for portraits of that size," Elisabeth grumbled, noting that she even added Laetitia at no additional cost.

Caroline had wanted François Gérard to paint her portrait, but he was so in demand that he couldn't fit her in. The disappointed sitter behaved dis-respectfully toward Elisabeth. She skipped so many appointments that the fashions in hairstyles, clothes, and jewelry changed between sittings, and Caroline insisted that Elisabeth update the painting every time. Although the artist didn't dare scold her, she made sure that Caroline could overhear her say, "I have painted authentic princesses who never made me wait." The experience was miserable for the artist; however, her talent shines as ever in this rendering of Caroline, who is depicted in exquisite detail—from her high-waisted dress trimmed with gold filigree to the pearls that adorn her ears, neck, wrist, and belt clasped with a large cameo.

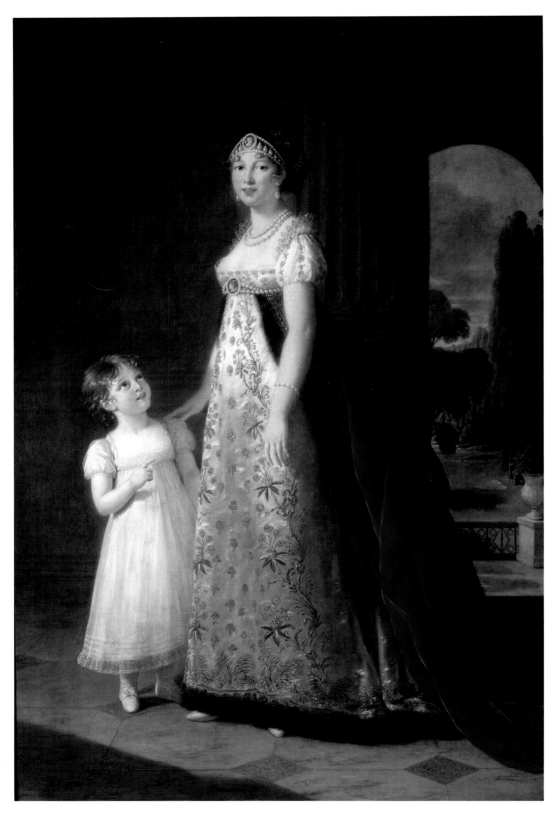

Caroline Murat and Her Daughter, 1807

Elisabeth expertly renders rich textures and brilliant colors in this state portrait, which shows Caroline all decked out in her finery. Caroline's sumptuous red velvet train trails behind her, and her luminous white silk dress, embroidered with gold thread, shimmers next to the white cotton dress worn by her daughter. Both sitters wear the high-waisted style popularized by Empress Josephine. Delicate ankle boots or slippers, made from soft leather and silk, complete their looks.

Mountain High

"I resumed my peaceful way of life once I no longer had to worry about the portrait of Mrs. Murat . . . but my taste for travel was not entirely sated. I had not yet seen Switzerland, and I burned with the desire to go and be in nature." Though her first journey as a solitary woman had been a run for her life, it had opened Elisabeth's eyes to the world. Nearly two decades later, travel and adventure had become habits she had no desire to break.

"If you are afraid of ravines, I would not suggest that you drive along the Evêché-Basel road," wrote Elisabeth, who described her state of wonder at the magnificent views as her carriage careened along the edges of sheer cliffs. She would make two trips to Switzerland between 1807 and 1809, traversing the beautiful country. As always, she received invitations to dine and stay with notable people wishing to meet the illustrious artist.

The French author Anne Louise Germaine de Staël-Holstein, better known as Madame de Staël, invited Elisabeth to stay a week with her in Coppet, in her family's castle on Lake Geneva. Napoleon had banished Anne Louise for repeatedly criticizing his imperialism. Having just read the author's novel *Corinne, or Italy*, Elisabeth suggested painting a portrait of her host as her main character, dressed in ancient Greek costume.

On her second Swiss excursion, the artist focused on the breathtaking landscape, capturing the colors of the sky and reflections of the sun on the hillsides in two hundred pastel sketches. The highlight of this trip was the Festival of the Shepherds at Unspunnen, an event that dated back to the thirteenth century. "Madame de Staël and I were so moved by this solemn

The festival, as depicted by Elisabeth, appears to be a picturesque and charming celebration in the midst of verdant and snowcapped mountains. The artist places herself in the foreground, wrapped in a red shawl, sitting in a meadow, with the Count of Grammont chivalrously holding her box of pastels. Games of strength take place, most notably wrestling and shot-putting. Yodeling and traditional dances added to the liveliness of the event.

Elisabeth found herself with Madame de Staël as they watched the opening of the festival. Meant to celebrate the country's heritage, the event that year also represented solidarity against French aggression. Elisabeth and Anne Louise, united in their opposition to Napoleon, likely sympathized with the nationalistic impulse behind the festival.

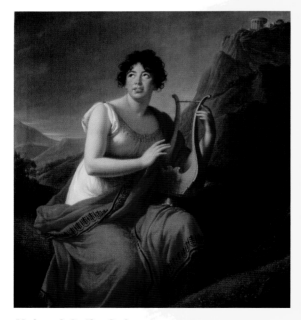

Madame de Staël as Corinne at Cape Miseno, 1807–9

The Outspoken Madame de Staël

The daughter of the finance minister Jacques Necker, Anne Louise Germaine de Staël-Holstein occupied an elevated place in Parisian society. She exercised her power not through the sword but through the word, writing daringly on political and social topics. She also hosted a lively salon well known for its nonconformist views on government. She was a thorn in Napoleon's side, and he banished her from Paris.

The painting *Madame de Staël as Corinne at Cape Miseno* depicts Anne Louise as the protagonist of her best-known novel, *Corinne, or Italy*. Elisabeth was inspired by the character of Corinne, who was a poet, musician, and artist. Popular as a dramatic romance, the book would also have been recognized as a thinly veiled denunciation of Napoleon's conquest of Italy. In this portrait, the figure holds a lyre—a stringed instrument and the symbol of poets—and is seated on a rock, gazing heavenward as if inspired by the gods. An imaginary landscape includes one reference to Italy: a pantheon structure almost hidden at the very top of the mountain.

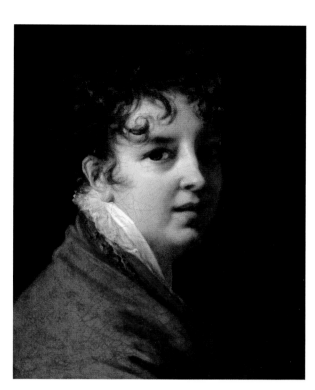

Self-Portrait, **1808–9**

Elisabeth painted her last self-portrait as a way to thank one of her hosts in Switzerland, Franz Niklaus König, a painter of landscapes, portraits, and everyday scenes. Franz must have considered himself fortunate to host the famous Elisabeth for two weeks. He participated in the Unspunnenfest that Elisabeth depicted in 1808. This portrait reflects the closeness Elisabeth felt with Franz and his wife, friends for whom she did not have to primp and preen. With her hair pinned up and cheeks flushed, Elisabeth seems to be in midconversation with her friends.

Self-Portrait with a Hat **by Rembrandt van Rijn, 1634–35**

No artist before Rembrandt painted as many self-portraits as he did, about eighty over his long career. He surrendered to the truth of looking in a mirror, unsparingly rendering his aging face and changing states of mind.

procession, this pastoral music, that we squeezed each other's hands without uttering a word but both brimming with tears. I shall never forget this moment of shared sensibility."

Country Retreat

After Elisabeth returned to France, she painted another self-portrait—this time without the exuberance she expressed in previous works. She depicts herself plainly—with neither adornments nor a smile—only her luminous face against a dark background, and a stroke of white paint to indicate her collar. Her face reflects her age, about fifty-four, which was advanced given that life expectancy for women in France at that time was around thirty-three years. The composition recalls a number of self-portraits by Rembrandt, one of which was in the collection of the Louvre at the time, as well as several works by other Northern European artists in Pierre's collection.

Elisabeth's Last Salon

The 1824 Salon of Painting and Sculpture, known in postrevolutionary times simply as the Salon, opened on August 25 of that year. Before photography was invented, commemorative paintings like this one provided visual records of special events. Two women are visible to the far right of the crowd: Lizinska de Mirbel, a popular painter of miniatures, and Louise Marie-Jeanne Hersent-Mauduit, a portrait and history painter. Above King Charles's head prominently hangs *The Vow of Louis XIII* by Jean Auguste Dominique Ingres. In the same room Eugène Delacroix exhibited *The Massacre at Chios*. Elisabeth's close friend Antoine Jean Gros painted a portrait of Jean Antoine Chaptal, a famous scientist and industrialist. The press made no mention of Elisabeth's two entries, portraits of Count Emmanuel Nikolayevich Tolstoy and the Duchess of Berry.

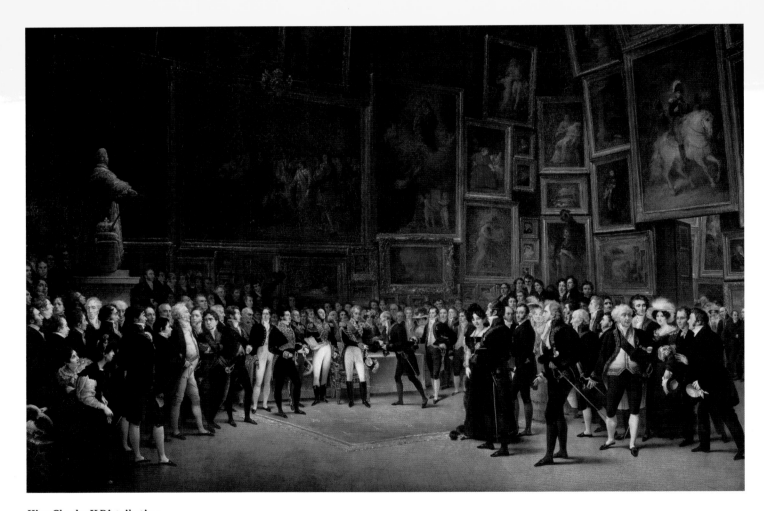

King Charles X Distributing Awards to the Artists at the End of the Salon of 1824, in the Grand Salon at the Louvre by François-Joseph Heim, 1827

Elisabeth purchased a house in the rural town of Louveciennes, twenty-five miles from the Hôtel Le Brun, where she hoped to find contentment amid the natural beauty. A few years later, on August 7, 1813, her ex-husband Pierre died of cancer at the age of sixty-five. He bequeathed to Julie his home and its extraordinary collection of art; unfortunately, she also inherited his debts and mortgages. In her memoir Elisabeth reflected thoughtfully on her relationship with Pierre, acknowledging that although she had not been married to him for years, she grieved his death: "To be sure, I had had no relations with him for a long time, but I was nonetheless painfully affected by his death. One cannot without regrets find oneself separated forever from a man to whom one was attached by a bond as intimate as marriage."

Though political disturbances had shaped the course of Elisabeth's life and career, the artist had rarely experienced war herself. But on a spring day in 1814, Prussian troops invaded Louveciennes and at the same time entered Paris. They wreaked havoc on the town, pillaging and burning houses and the local church. At 11:00 p.m. on March 31, three Prussian soldiers entered the artist's bedroom and stole her valuables. Elisabeth immediately fled her home and sought refuge with five other women for a few nights, until she could make her way back to Paris. It was her closest encounter with the violence that had pervaded French life since the monarchy was toppled. Little wonder, then, that she welcomed the calm that came when a coalition of European countries defeated Napoleon, and King Louis XVIII ascended to the throne. Elisabeth was eager to see the new constitutional monarch (brother of Louis XVI and brother-in-law to Marie Antoinette), who had remained in exile during the Revolution. One Sunday, Elisabeth joined the public to see the new king, who recognized her in the crowd and extended his hand. Elisabeth mentioned in her memoir, with some false modesty, that onlookers mistook her for a great lady, as Louis XVIII "approached no other woman."

Julie had been living in Paris since 1804, having made some attempts to support herself as an artist, though she and her mother were often at odds over money and Julie's choice of friends. Their relationship was always complicated, but when Julie fell seriously ill in 1819 at the age of thirty-nine, Elisabeth hurried to her side. "I had rushed to be near her as soon as I learned that she was ailing, but the illness progressed rapidly. Words cannot express how I felt when I lost all hope that she might survive. When I saw her that final day, I gazed upon her beautiful face, completely ravaged. Alas, she was so young! Was she not supposed to survive me?"

Julie's tragic early death was followed a year later by that of Elisabeth's brother, Etienne. The artist wrote, "So much grief in so short a time broke my spirit." She sought consolation on a trip to the French city of Bordeaux before settling back into her routine, although she now worked at a slower pace. Elisabeth painted a portrait of Count Emmanuel Tolstoy, whose mother

Count Emmanuel Tolstoy, 1823

After she moved back to France,
Elisabeth stayed in touch with
Russian nobles she had met in
Saint Petersburg. Many upper-
class Russians traveled frequently
to Paris, the cultural capital of
Europe. Twenty-seven years after
painting Countess Anna Tolstaya in
Saint Petersburg, Elisabeth made
this portrait of her youngest son,
Emmanuel, when he was twenty-
one. The artist stripped this portrait
of any excess. A diagonal shadow
falls across the background, pro-
viding a sense of depth. Emmanuel
wears a simple velvet mantle with
a red cowl. The collar of a white
shirt elongates his delicate neck,
and his peach complexion highlights
his piercing blue eyes. Sadly, both
Emmanuel and his mother died
two years after Elisabeth painted
this work.

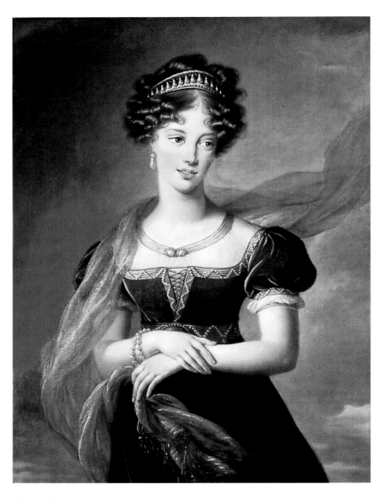

**The Duchess of Berry in
a Blue Velvet Dress, 1824**

Marie Caroline of Bourbon-
Sicile, Duchess of Berry, was
a controversial and important
political figure in early nineteenth-
century France. In 1816 she
married Charles Ferdinand, Duke
of Berry, the younger son of the
future king, Charles X of France,
linking her to the French royal
family. Marie Caroline played an
important role in her son's claim
to the French throne as Henry V.
Here her rich blue velvet gown
and opulent pearl drop earrings
echo the dress and jewels worn
by Marie Antoinette in her royal
portrait from 1788 (p. 61).
Whether this similarity was an
intentional reference or a coin-
cidence, Elisabeth remained a
steadfast monarchist and would
have supported the restoration
of the monarchy after the fall
of Napoleon.

and uncle she had painted years before, and she captured the likeness of the Duchess of Berry in a blue velvet dress. She exhibited both works at the 1824 Paris Salon. These entries would mark her last time participating in the elite academy that had accepted her four decades earlier, when she never could have imagined the scope of her future success.

Remember Me

Why did Elisabeth decide to write her memoir, simply titled *Souvenirs* (in English, *Memories*)? In her later years, she spent much of her time with her two nieces, Caroline Rivière (Etienne's daughter) and Eugénie Tripier Le Franc (Pierre's niece). Eugénie was an artist in her own right whose talent for painting genuinely delighted her aunt. Toward the very end of her memoir, Elisabeth alluded to missing Julie, and she mentioned that her nieces "have helped me to rediscover the feelings of a mother. . . . I look forward to spending my final years with these two treasured people, concluding a life that was nomadic but nevertheless steady, productive, and honorable."

Elisabeth's literary friend Catherine Dolgorukova had suggested that the artist produce a memoir, and in 1834 Caroline and Eugénie began helping their aunt with her writing. Elisabeth didn't necessarily recall dates, nor did she relate her experiences in chronological order. At this stage in her life, she had nothing more to prove; she held an established position in the art world and in society at large. She felt free to share her brash opinions and tell her story from her own point of view. What mattered most to Elisabeth was presenting the circumstances of her life as she saw them, not leaving any part open to interpretation. She had a unique story to tell, as a woman who dared to challenge the expectations of her era to achieve a spectacular artistic career, socialize with the most influential people of her day, receive honors from the most prestigious art academies, navigate tumultuous political tides, and explore the dramatic beauty of nature on her own.

In 1835 she authorized the publisher Hippolyte Fournier to print 1,500 copies of her memoir, which would be released in installments. The first came out in 1835; the second and third volumes appeared in 1837. At age eighty, Elisabeth thus completed her life's work by shaping a deeply passionate autobiography rich in historical and personal detail. Arguably, Elisabeth's memoir formed her legacy as much as her paintings did.

Elisabeth Louise Vigée Le Brun died on March 30, 1842, at the age of eighty-six. She had painted approximately eight hundred canvases, about one hundred of which were exhibited in Paris between 1774 and 1824. Paintings that Eugénie donated to the Louvre in 1843 were Elisabeth's first works in that or any museum. Today, Elisabeth's art is housed in museums and collections around the world—from Japan to Russia, from France to the United States.

Self-Portrait by Eugénie Tripier Le Franc, 1820–29

Though we cannot be absolutely certain, this ink, graphite, and watercolor self-portrait may have been painted by Elisabeth's niece Eugénie. In any case, it is an interesting document of a working woman artist. The painter's toque, a type of hat, was less a fashion statement than a practical way to keep hair out the painter's face and a place to wipe brushes and hands. In her left hand the artist holds the tools of her trade, a paint palette and a maul stick, which is a device used to help steady the artist's hand while painting fine details.

She understood that museums safeguard not only objects but also reputations, as do books and other publications. Between her art and her memoir, her accomplishments could not be erased from the historical record.

Elisabeth broke new ground for future women artists through her actions and accomplishments. Gradually art history has become more inclusive and comprehensive, weaving in narratives and works that disrupt mainstream ideas. Many of Elisabeth's female sitters also played roles in shaping history, politics, and culture. We can only imagine the fascinating conversations that may have taken place while Elisabeth sat across from her subjects, mixing her paints with a palette knife, dabbing her brush, and committing lives to posterity in vibrant color.

Acknowledgments

This is a book about Elisabeth Vigée Le Brun, a painter of portraits in eighteenth-century France who, as a woman, succeeded in her profession and broke barriers along the way. Elisabeth is equally recognized for her lively memoir, which records the events and people who shaped her life. Were it not for this autobiography, we could still trace the story of this prolific artist through her works, on view in many prominent museums around the world. We have a remarkable chalk drawing, executed by Elisabeth at age ten, depicting her brother, Etienne. Her precocious talent came to the attention of the Queen of France, Marie Antoinette, who sat for Elisabeth many times; the first was when the painter was twenty-three and the queen was only seven months her junior. The nature of their relationship was less a friendship, as they were not social equals, but certainly one of mutual admiration.

The dramatic fall of the monarchy compelled Elisabeth to seek refuge outside France. The very relationship that endangered her also brought powerful and lucrative connections throughout the dense network of European royal courts. She eventually settled in Saint Petersburg, having been invited there by one of the most influential leaders in Russian history. Elisabeth's life has been described as an "odyssey" for good reason: like Odysseus, she spent many years journeying abroad, and her travels were characterized by adventures—some arduous and perilous, others exciting and profoundly life-changing. By the time the artist wended her way back home, perhaps she already had in mind the idea of writing a memoir so as not to forget the stories behind her portraits as well as the range of her emotions as strangers accepted her into their lives, showering her with lucrative commissions, honors, and invitations to set up residence in their country.

Throughout her memoir, Elisabeth conveys her love for her father, mother, daughter, and nieces; expresses gratitude to her husband; and portrays the human side of Marie Antoinette, a figure who occupied a controversial role in the French monarchy. Some of the artist's most successful portraits depict women of enormous power, influence, and creative talent whose individual stories have yet to be given fair consideration. This book only touches on the lives of those women, some of whom wielded political power behind the scenes and yet whose portraits often suggested a conventional female role as "merely" wife and mother.

As a mother myself, I found Elisabeth's relationship with her daughter, Julie, particularly poignant. She, Julie, and Julie's governess, Mrs. Charot, braved the rutted roads of Europe to flee political instability for the security and safety of kingdoms still untouched by revolution. Their extensive travels influenced Elisabeth's unusual curriculum for Julie, which included learning multiple languages, geography, and how to paint. Although in her memoir Elisabeth doesn't dwell on Julie, her paintings of her daughter—some with her and some of Julie alone—express a mother's abiding love and admiration for her only child, whom she tragically lost twice: first to an ill-fated marriage and then to a terrible disease.

I deeply admire and relied upon the scholarship of Joseph Baillio, Katharine Baetjer, and Paul Lang published in the Metropolitan Museum of Art's catalogue *Vigée Le Brun* (2016), which has been an indispensable resource. That catalogue has been made available online in its entirety. My book also honors Gita May and Mary D. Sheriff, whose groundbreaking biographies of Elisabeth served as guideposts during my journey with the artist.

If it were not for another Elizabeth, I would not have written this story about Elisabeth Vigée Le Brun. It is my good fortune to have worked with Elizabeth Nicholson, acting editor in chief at Getty Publications, benefiting from her editorial wisdom. She first imagined the multiple points of connection between the life of this eighteenth-century painter and those of young adults in the twenty-first century who continue to face gender-related challenges. Because of a remarkable creative production team, each aspect of this project came together seamlessly and beyond what I could have envisioned. I am profoundly indebted to Amanda Sparrow, copy editor, Dani Grossman, designer, Molly McGeehan, production coordinator, and Nancy Rivera, associate rights specialist, for bringing Elisabeth vividly to life in this publication. I would also like to acknowledge the invaluable assistance of Getty graduate interns Kate Justement and Alex Hallenbeck, assistant editor Darryl Oliver, and Getty Marrow undergraduate intern Maya Le.

I am most grateful to Frederick Brown, whose elegant translations and interpretations of Elisabeth's prose helped make this historical figure a living presence for me. He read my manuscript with fine critical intelligence. I will always treasure the hours spent poring over passages, debating the fine points of Elisabeth's turns of phrase and specificity of word choice. Thomas Grasse's encouragement buoyed my spirits in the final stages of writing this book, as did his enthusiasm upon seeing the paintings for the first time in the galleries of the Louvre. In writing this book, I thought often of my father, Lee Pomeroy, who would have joined me on this expedition, reading up on Elisabeth's life and opining on the book design. Finally, this book is a nod to my mother, Sarah Pomeroy, whose pioneering explorations in women's studies began when I myself was a YA reader. It was she who first taught me to ask: Where were the women?

Notes

Throughout this book are quotations from Elisabeth Vigée Le Brun's three-volume memoir: *Souvenirs de Madame Louise-Élisabeth Vigée-Lebrun* (Paris: H. Fournier, 1835). Except as noted below, all quotations from *Souvenirs* were translated into English by Frederick Brown and Jordana Pomeroy. Jordana Pomeroy adapted translated quotations on the following pages from *The Memoirs of Elisabeth Vigée-Lebrun*, translated by Siân Evans (London: Camden Press, 1989): 53, 57, 61, 66, 69, 71, 72, 75, 93, 95, 97, 101.

Chapter 1

10 "Everyone has a crayon in his hand": Shelley, "Painting in the Dry Manner."

11 "two or three thousand": Drake, "The Wet Nurse in France in the Eighteenth Century."

11 The demand became: Cowan, "The Secret Lives of Wet Nurses in 18th-Century France."

13 Much of the school's curriculum: O'Connor, *In Pursuit of Politics*, 18–25.

15 The middle and working classes: Coquery, "The Language of Success."

20 "this young virtuosa": Anonymous critic quoted in Baillio, Baetjer, and Lang, *Vigée Le Brun*, 67.

Chapter 2

23 Pierre selected his attire: Speith and Fumaroli, *Revolutionary Paris and the Market for Netherlandish Art*, 129.

23 But in addition: Baetjer, "The Women of the French Royal Academy," in Baillio, Baetjer, and Lang, *Vigée Le Brun*, 34, 43.

24 "that which is lacking": Roussel, *Physical and Moral System of Women*; Chauvot de Beauchêne quoted in Sheriff, "The Woman-Artist Question," 43, 45.

24 "I offer a foolproof way": Levy, Applewhite, and Johnson, *Women in Revolutionary Paris*, 96.

25 Pierre Le Brun would become: Wester, "Life and Work of Jean-Baptiste Pierre Le Brun (1748–1813)."

28 A year or two after that: Wester, "Life and Work of Jean-Baptiste Pierre Le Brun (1748–1813)."

28 It would not have escaped: Schama, *The Embarrassment of Riches*, 375.

28 The ideal woman of the 1770s: van Cleave, "Women's Hairstyles & Cosmetics of the 18th Century: France & England, 1750–1790."

28 The mid-1770s saw: Delalex, Maral, and Milovanovic, *Marie-Antoinette*, 88.

30 "can never be useful": Auricchio, *Adélaïde Labille-Guiard*, 29.

30 Tired of carrying around: Delalex, Maral, and Milovanovic, *Marie-Antoinette*, 128.

32 "She is a young and pretty woman": This quote was probably by one of the authors of *Mémoires Secrets pour Servir à l'Histoire de la République des Lettres en France depuis 1762 jusqu'à Nos Jours* (Secret Memoirs Serving as a History of the Republic of Letters in France from 1762 until Our Day).

33 The Black population of France: Banat, *The Chevalier de Saint-Georges*; Chatman, "There are no Slaves in France."

33 "the most accomplished man in Europe": Adams, *The Adams Papers, Diary and Autobiography of John Adams*, [May 1779].

41 One unspoken reason: Chrisman-Campbell, *Fashion Victims*, 192.

42 Marie Antoinette could no longer: Barker, "'Let Them Eat Cake.'"

48 Even with his troops: Auricchio, *The Marquis*, 204–8.

Chapter 3

53 Elisabeth, Julie, and Mrs. Charot spent: Baillio, Baetjer, and Lang, *Vigée Le Brun*, 241–42.

54 Angelica painted a self-portrait: Rice and Eisenberg, "Angelica Kauffman's Uffizi Self-Portrait."

59 She played a highly visible role as queen: Acton, *The Bourbons of Naples (1734–1825)*.

61 Emma was the daughter: Newman, "Noctes Neapolitanae."

63 Some confusion surrounds: Christie's, "Portrait of Emma Hart, later Lady Hamilton (1765–1815), as the Cumaen Sibyl."

Chapter 4

74 Elisabeth framed his impish youthful face: Baillio, Baetjer, and Lang, *Vigée Le Brun*, 167.

75 The interior was painted blue: German traveler Franz Jenne's description quoted in Bischoff, "Madame Vigée Le Brun at the Court of Catherine the Great," 30–45.

75 She carried the torch: Whittaker, "Catherine the Great and the Art of Collecting: Acquiring the Paintings that Founded the Hermitage."

75 The invitation: Blakesley, "Pride and the Politics of Nationality in Russia's Imperial Academy of Fine Arts, 1757–1807."

82 Especially gratifying to Elisabeth: http://www.pastellists.com/Articles/LEBRUNj.pdf

85 "Her room is like": Scarisbrick, "Imperial Splendour: Catherine II and Her Jewellery."

Chapter 5

91 The dress she wears: Higonnet, *Liberty Equality Fashion*.

92 Baron François Pascal Simon Gérard: Galitz, "François Gérard: Portraiture, Scandal, and the Art of Power in Napoleonic France."

93 He is credited with advising: Oliver, *Jean-Baptiste-Pierre LeBrun: In Pursuit of Art (1748–1813)*, 44–46.

94 These portraits of eyes: Shusan, *Lover's Eyes: Eye Miniatures from the Skier Collection*.

103 Elisabeth didn't necessarily recall dates: Oliver, *Jean-Baptiste-Pierre LeBrun: In Pursuit of Art (1748–1813)*, 64.

Selected Sources

Acton, Harold. *The Bourbons of Naples (1734–1825)*. London: Methuen, 1956.

Adams, John. *The Adams Papers, Diary and Autobiography of John Adams*, vol. 2, 1771–81. Edited by L. H. Butterfield. Cambridge, MA: Harvard University Press, 1961. Accessed through *Founders Online*, CMS 14.18 National Archives, https://founders.archives.gov /documents/Adams/01-02 -02-0009-0004.

Auricchio, Laura. *Adélaïde Labille-Guiard: Artist in the Age of Revolution*. Los Angeles: J. Paul Getty Museum, 2009.

Auricchio, Laura. *The Marquis: Lafayette Reconsidered*. New York: Knopf, 2014.

Baetjer, Katharine. "The Women of the French Royal Academy." In Baillio, Baetjer, and Lang, 33–45.

Baillio, Joseph, Katharine Baetjer, and Paul Lang. *Vigée Le Brun*. New York: Metropolitan Museum of Art, 2016.

Baillio, Joseph, and Xavier Salmon. *Élisabeth Vigée Le Brun*. Paris: Grand Palais, Galeries nationales, 2016.

Banat, Gabriel. *The Chevalier de Saint-Georges: Virtuoso of the Sword and the Bow*. New York: Pendragon, 2006.

Barker, Nancy N. "'Let Them Eat Cake': The Mythical Marie Antoinette and the French Revolution." *The Historian* 55, no. 4 (Summer 1993): 709–24.

Bischoff, Ilse. "Madame Vigée Le Brun at the Court of Catherine the Great." *The Russian Review* 24, no. 1 (January 1965): 30–45.

Blakesley, Rosalind P. "Pride and the Politics of Nationality in Russia's Imperial Academy of Fine Arts, 1757–1807." *Art History* 33, no. 5 (December 2010): 800–835.

Blakesley, Rosalind P. *Women Artists in the Reign of Catherine the Great*. London: Lund Humphries, 2023.

Cage, E. Claire. "The Sartorial Self: Neoclassical Fashion and Gender Identity in France, 1797–1804." *Eighteenth-Century Studies* 42, no. 2 (Winter 2009): 193–215.

Carter, Karen E. "The Science of Salvation: French Diocesan Catechisms and Catholic Reform (1650–1800)." *The Catholic Historical Review* 96, no. 2 (April 2010): 234–61.

Chatman, Samuel L. "'There are no Slaves in France': A Re-Examination of Slave Laws in Eighteenth Century France." *Journal of Negro History* 85, no. 3 (Summer 2000): 144–53.

Chrisman-Campbell, Kimberly. *Fashion Victims: Dress at the Court of Louis XVI and Marie-Antoinette*. New Haven, CT: Yale University Press, 2015.

Christie's. "Portrait of Emma Hart, later Lady Hamilton (1765-1815), as the Cumaen Sibyl." Live Auction 17195, Old Masters Evening Sale. Accessed August 12, 2024. www.christies.com/en/lot /lot-6217439.

Chrościcki, Juliusz A. "The Recovered Modello of P. P. Rubens' 'Disembarkation at Marseilles': The Problem of Control and Censorship in the Cycle of 'Life of Maria de'Medici.'" *Artibus et Historiae* 26, no. 51 (2005): 221–49.

Coquery, Natacha. "The Language of Success: Marketing and Distributing Semi-Luxury Goods in Eighteenth-Century Paris." *Journal of Design History* 17, no. 1 (2004): 71–89.

Cowan, Lissa M. "The Secret Lives of Wet Nurses in 18th-Century France." *Reading the Past: News, Views, and Reviews of Historical Fiction* (blog). October 29, 2013. https://readingthepast.blogspot .com/2013/10/the-secret-lives -of-wet-nurses-in-18th.html.

Delalex, Hélène, Alexandre Maral, and Nicolas Milovanovic. *Marie-Antoinette*. Los Angeles: J. Paul Getty Museum, 2016.

Drake, T. G. H. "The Wet Nurse in France in the Eighteenth Century." *Bulletin of the History of Medicine* 8, no. 7 (July 1940): 934–48.

Galitz, Kathryn Calley. "François Gérard: Portraiture, Scandal, and the Art of Power in Napoleonic France." *The Metropolitan Museum*

of Art Bulletin 71, no. 1 (Summer 2013): 1–48.

Higonnet, Anne. *Liberty Equality Fashion: The Women Who Styled the French Revolution*. New York: W. W. Norton, 2024.

Jeffares, Neil. "Boquet, Jeanne-Angélique, Mme Jean Charny." *Dictionary of Pastellists before 1800: Online Edition*. Updated May 15, 2022. www.pastellists .com/Articles/Bocquet.pdf.

Jeffares, Neil. "Le Brun, Jeanne-Julie-Louise, Mme Gaëtan-Bernard Nigris." *Dictionary of Pastellists before 1800: Online Edition*. Updated February 19, 2023. www.pastellists.com /Articles/LEBRUNj.pdf.

Levy, Darline Gay, Harriet Bronson Applewhite, and Mary Durham Johnson, eds. *Women in Revolutionary Paris 1789-1795*. Champaign, Illinois: University of Illinois Press, 1979.

Massie, Robert K. *Catherine the Great: Portrait of a Woman*. New York: Random House, 2012.

May, Gita. *Elisabeth Vigée Le Brun: The Odyssey of an Artist in an Age of Revolution*. New Haven, CT: Yale University Press, 2005.

Newman, Frances. "Noctes Neapolitanae: Sir William Hamilton and Emma, Lady Hamilton at the Court of Ferdinand IV." *Illinois Classical Studies* 27/28 (2002–3): 213–32.

O'Connor, Adrian. *In Pursuit of Politics: Education and Revolution in Eighteenth-Century France*. Manchester: Manchester University Press, 2017.

Oliver, Bette W. *From Royal to National: The Louvre Museum and the Bibliothèque Nationale*. Lanham, MD: Lexington Books, 2007.

Oliver, Bette W. *Jean-Baptiste-Pierre LeBrun: In Pursuit of Art (1748–1813)*. Lanham, MD: Lexington Books, 2018.

Oliver, Bette W. *Surviving the French Revolution*. Lanham, MD: Lexington Books, 2013.

Pacini, Giulia. "Hidden Politics in Germaine de Staël's *Corinne ou l'Italie*." *French Forum* 24, no. 2 (May 1999): 163–77.

Pomeroy, Jordana, Laura Auricchio, Melissa Lee Hyde, and Mary D. Sheriff. *Royalists to Romantics: Women Artists from the Louvre, Versailles, and Other French National Collections*. Washington, DC: National Museum of Women in the Arts, 2012.

Pomeroy, Jordana, Rosalind P. Blakesley, Vladimir Yu Matveyev, and Elizaveta P. Renne. *An Imperial Collection: Women Artists from the State Hermitage Museum*. Washington, DC: National Museum of Women in the Arts, 2003.

Rice, Louise, and Ruth Eisenberg. "Angelica Kauffmann's Uffizi Self-Portrait." *Gazette des Beaux-Arts* 117 (March 1991): 123–26.

Robb, Graham. *The Discovery of France*. New York: W. W. Norton, 2007.

Rosenthal, Angela. *Angelica Kauffman: Art and Sensibility*. New Haven, CT: Yale University Press, 2006.

Roussel, Pierre. *Système physique et moral de la femme ou Tableau philosophique de la constitution, de l'état organique, du tempérament, des moeurs, & des fonctions propres au sexe* [Physical and moral system of women or Philosophical table of the constitution, organic state, temperament, morals, & functions specific to the sex]. Paris: Chez Vincent, 1775.

Scarisbrick, Diana. "Imperial Splendour: Catherine II and Her Jewellery." Sotheby's. October 26, 2016. www.sothebys.com /en/articles/imperial-splendour -catherine-ii-her-jewellery.

Schama, Simon. *The Embarrassment of Riches: An Interpretation of Dutch Culture in the Golden Age*. New York: Alfred A. Knopf, 1988.

Shelley, Marjorie. "Painting in the Dry Manner: The Flourishing of Pastel in 18th-Century Europe." *The Metropolitan Museum of Art Bulletin* 68, no. 4 (Spring 2011): 4–56.

Sheriff, Mary D. *The Exceptional Woman: Élisabeth Vigée-Lebrun and the Cultural Politics of Art*. Chicago: University of Chicago Press, 1996.

Image Credits

Sheriff, Mary D. "The Woman-Artist Question." In Pomeroy, Auricchio, Hyde, and Sheriff, 43–50.

Shushan, Elle, ed. *Lover's Eyes: Eye Miniatures from the Skier Collection*. London: D. Giles Ltd., 2021.

Speith, Darius A., and Marc Fumaroli. *Revolutionary Paris and the Market for Netherlandish Art*. Leiden: Brill, 2018.

Spies-Gans, Paris Amanda. "Exceptional, but not Exceptions: Public Exhibitions and the Rise of the Woman Artist in London and Paris, 1760–1830." *Eighteenth-Century Studies* 51, no. 4 (Summer 2018): 393–416.

Sussman, George D. *Selling Mothers' Milk: The Wet-Nursing Business in France, 1715–1914*. Champaign: University of Illinois Press, 1982.

van Cleave, Kendra. "Women's Hairstyles & Cosmetics of the 18th Century: France & England, 1750–1790," Demodé Historical Costume Projects & Resources. Accessed August 13, 2024. www.demodecouture.com /hairstyles-cosmetics-18th-century.

Vigée Lebrun, Elisabeth. *The Memoirs of Elisabeth Vigée-Le Brun*. Translated by Siân Evans. London: Camden Press, 1989.

Vigée Le Brun, Elisabeth. *Souvenirs de Madame Louise-Élisabeth Vigée-Lebrun*. 3 vols. Paris: H. Fournier, 1835.

Weber, Caroline. *Queen of Fashion: What Marie Antoinette Wore to the Revolution*. New York: Picador, 2007.

Wester, Peter. "Life and Work of Jean-Baptiste Pierre Le Brun (1748–1813)." Essential Vermeer 4.0. August 2015. www.essentialvermeer.com /history/le_brun_biography.html.

Whittaker, Cynthia Hyla. "Catherine the Great and the Art of Collecting: Acquiring the Paintings that Founded the Hermitage." In *Word and Image in Russian History: Essays in Honor of Gary Marker*, edited by Daniel H. Kaiser, Maria di Salvo, and Valerie A. Kivelson, 147–71. Brighton, MA: Academic Studies Press, 2015.

Index

Published by Getty Publications, Los Angeles
1200 Getty Center Drive, Suite 500
Los Angeles, California 90049-1682
getty.edu/publications

Elizabeth S. G. Nicholson, *Project Editor*
Amanda Sparrow, *Copy Editor*
Dani Grossman, *Designer*
Molly McGeehan, *Production*
Nancy Rivera, *Image and Rights Acquisition*

Distributed in North America by
ABRAMS, New York

Distributed outside North America by
Yale University Press, London

Printed in China

The complete manuscript of this work was peer reviewed through
a single-masked process in which the reviewers remained anonymous.

Library of Congress Cataloging-in-Publication Data
Names: Pomeroy, Jordana, 1962– author. | Vigée-Lebrun, Louise-Elisabeth,
 1755–1842.
Title: Daring : the life and art of Elisabeth Vigée Le Brun / Jordana
 Pomeroy.
Description: Los Angeles : Getty Publications, [2025] | Includes
 bibliographical references and index. | Audience: Ages 13–18 | Audience:
 Grades 10–12 | Summary: "The dramatic life story of Elisabeth Vigée Le
 Brun, one of the greatest portrait painters of all time"—Provided by
 publisher.
Identifiers: LCCN 2024042387 (print) | LCCN 2024042388 (ebook) | ISBN
 9781947440104 (hardback) | ISBN 9781606069110 (epub)
Subjects: LCSH: Vigée-Lebrun, Louise-Elisabeth, 1755-1842. | Portrait
 painters—France—Biography. | Women painters—France—Biography. |
 LCGFT: Biographies.
Classification: LCC ND1329.V53 P66 2025 (print) | LCC ND1329.V53 (ebook)
 | DDC 759.4 [B—dc23/eng/20241214
LC record available at https://lccn.loc.gov/2024042387
LC ebook record available at https://lccn.loc.gov/2024042388

Illustration Credits
Every effort has been made to contact the owners and photographers of images
reproduced here whose names do not appear in the captions or in the image
credits listed on p. 108. Anyone having further information concerning copyright
holders is asked to contact Getty Publications so this information can be included
in future printings.

Front cover: Elisabeth Vigée Le Brun, *Self-Portrait in a Straw Hat*, 1782 (detail, p. 29)
Back cover: Elisabeth Vigée Le Brun, *Marie Antoinette in Court Dress*, 1778 (detail, p. 26)
p. iii: Elisabeth Vigée Le Brun, *Self-Portrait*, 1790 (detail, p. 55)

Authorized Product Safety Representative in the European Union: Easy Access System
Europe, Mustamäe tee 50, 10621 Tallinn, Estonia, gpsr.requests@easproject.com